Ocean Duets

photographs by **MICHELE WESTMORLAND**

text by **BARBARA SLEEPER**

foreword by **DR. SYLVIA A. EARLE**

FULCRUM PUBLISHING
GOLDEN, COLORADO

Photographs © 2006 Michele Westmorland
Text © 2006 Barbara Sleeper
Foreword © 2006 Dr. Sylvia A. Earle

Library of Congress Cataloging-in-Publication Data

Westmorland, Michele.
 Ocean duets : photographs / by Michele
Westmorland ; text by Barbara Sleeper ;
foreword by Sylvia Earle.
 p. cm.
 ISBN-13: 978-1-55591-613-8 (pbk.)
 ISBN-10: 1-55591-613-9
 1. Marine biology–Pictorial works. I.
Sleeper, Barbara. II. Title.
 QH91.17.W47 2006
 779'.3209162–dc22

2006020309

ISBN-13: 978-1-55591-613-8
ISBN-10: 1-55591-613-9
Printed in China by P. Chan and Edward
0 9 8 7 6 5 4 3 2 1

Editorial: Katie Raymond, Faith Marcovecchio
Design: Ann W. Douden

Fulcrum Publishing
4690 Table Mountain Drive, Suite 100
Golden, Colorado 80403
800-992-2908 • 303-277-1623
www.fulcrumbooks.com

COVER
Spinecheek anemonefish
(PREMNAS BIACULEATUS)
in bulb tentacle sea anemone
(ENTACMAEA QUADRICOLOR)
Papua New Guinea

Only by using a digital camera was it possible to
capture the intense color of this fluorescing sea
anemone native to the Indo-Pacific Region.
The bulb tentacle, or bubble-tip, anemone is a
common reef species that can live for more than a
century, often growing into a large colonial cluster.
Armed with toxin-injecting nematocysts, anemones
use their weaponry to discourage
predation and to stun and capture
their prey—except for this dazzling
pair of spinecheek anemonefish that
are protected by a host-specific
mucous coating.

PREVIOUS PAGE
Bottlenose dolphins
(TURSIOPS TRUNCATUS)
Republic of Palau, Micronesia

A pair of bottlenose dolphins swims with graceful
beauty through the tropical waters near Palau.
Found worldwide, but not within 45 degrees of either
pole, bottlenose dolphins are named for their short,
stubby beaks. Whether spotting a few individuals
swimming near shore or a group of several hundred
moving across the open ocean in a cetaceous wave, a
dolphin encounter always leaves a lasting impression.

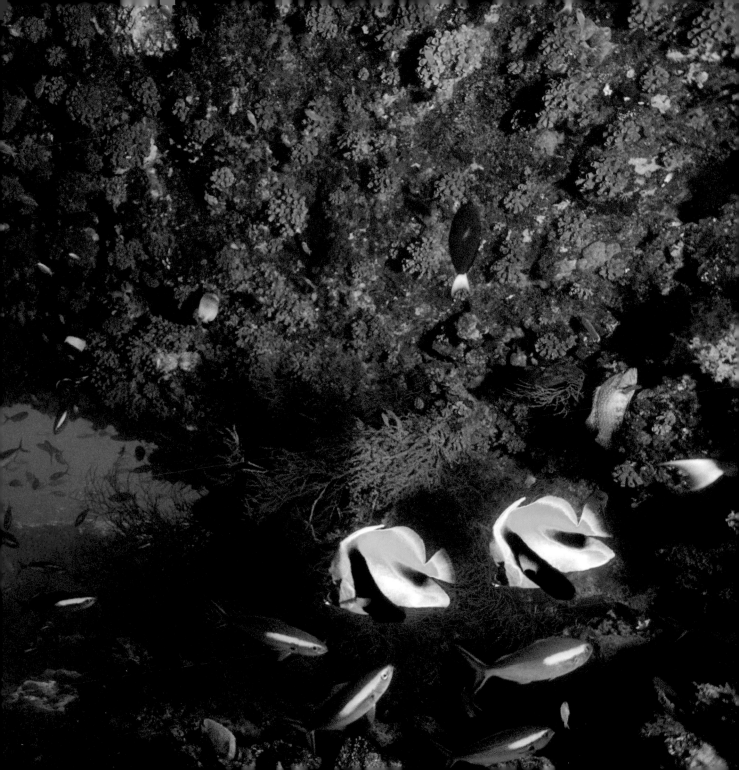

Without technology, the sea would be as fathomless as the distant stars.

When I was three, the ocean along the New Jersey shore first got my attention: a great wave knocked me off my feet, I fell in love, and ever after I have been irresistibly drawn, first to the cool, green Atlantic Ocean; later, to the Gulf of Mexico; and thereafter to other oceans, to reefs, raging surf, calm embayments, steep drop-offs, and the farthest reaches of the deep sea beyond. The "urge to submerge" came on early and continues still, seasoned and made more alluring by thousands of underwater hours, each one heightening the excitement of the last, as one discovery leads to another.

During my first underwater glimpse of an Indian Ocean reef, just off the south coast of Kenya, I felt like a child turned loose alone at F.A.O. Schwarz. I wanted to be everywhere at once, peering into the great, soft folds of clownfish anemones, poking at giant sea cucumbers, following pairs of yellow butterflyfish, standing on my head to get a better look at a spotted eel in an angled crevice, coaxing a tiny octopus from its lair. … It was easy to forget that I was supposed to be a serious scientist as I careened around, an amazingly

Dr. Sylvia A. Earle diving in the California Kelp Forest

PHOTO © KIP EVANS PHOTOGRAPHY

mobile "sponge" with flippers, absorbing and savoring every new image.

I have often looked longingly at the speed, agility, and gamboling grace of dolphins, who sometimes fling themselves aloft with deliberate twists and spins that easily surpass the finest human gymnastic displays, all the while keeping pace with a boat speeding alongside at 20 knots, sometimes more, and regularly staying submerged for several minutes with no apparent stress.

Even more impressive are their larger relatives, humpback whales. I had the opportunity to dive with these gentle giants in Hawaii. At close range, the sound of a singing whale is so intense that it is almost unbearable—like being in the front row during a Wagnerian opera. Air spaces in my head and body vibrated as the whale went through its repertoire of eerie wheeps, arcing trills, and low rumbling groans and sighs, ranging from ultralow bass through bubbling, rippling sequences, hee-haws, then to high, violinlike squeals. It seemed that the whale was equipped simultaneously with an orchestra—and a barnyard.

Longfin bannerfish
(HENIOCHUS ACUMINATUS)
Pot Luck Reef, Fiji Islands

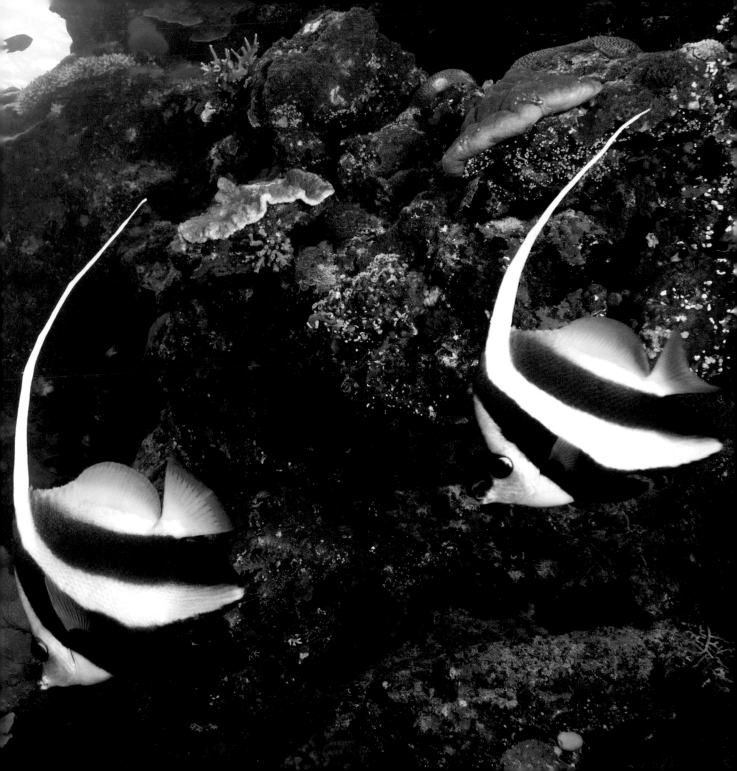

It doesn't matter where on Earth you live, everyone is utterly dependent on the existence of that lovely, living saltwater soup—the ocean. Our origins are there, reflected in the briny solution coursing through our veins and in the underlying chemistry that links us to all other life.

There's plenty of water in the universe without life, but nowhere is there life without water. The **living** ocean drives planetary chemistry, governs climate and weather, and otherwise provides the cornerstone of the life-support system for all creatures on our planet, from deep-sea starfish to desert sagebrush.

If I could journey back in time, one of the first places I would explore would be Florida's Gulf Coast a thousand years ago, to a world of deep reefs, shallow sea-grass meadows, and mangrove-bordered shores that I have climbed, swum, dived, and scrambled around during most of my life. I try to imagine gliding into this ocean as it was at the beginning of the last millennium—a sea filled with luminous night creatures, with starfish and sea hares, with bright-eyed puffer fish gentle as cows, and rays butterflying by with slow-motion grace. There would be plenty of sounds in the sea, from subtle snaps and sizzles of small crustaceans to warbles, grunts, pops, and hundreds of other variations produced by fish and marine mammals—but no throb of engines, no ping of depth sounders, no low rumble of mechanical or electronic subsea thunder.

Perhaps after returning from a visit far back into the history of the planet, certain creatures would be treated with more respect—especially those durable ones, like jellyfish and sharks and crustaceans, that have survived, more or less intact, through hundreds of millions of years. In fact, the next time you take a bite out of a large, pink prawn in your salad, reflect for a moment that you are eating one of those extraordinary sea creatures whose ancestry precedes ours by nearly half a billion years.

It is hard to comprehend that life in the oceans was and still is shaped primarily by ancient ocean processes involving continuous interactions among living organisms. Even today, the history of life on Earth can be read most completely in living sea creatures, responding still to the rhythms of deep time.

In fact, every breath we take is linked to the sea. This vast, three-dimensional realm, accounting for 97 percent of Earth's water, also makes up more than 95 percent of the biosphere, the planet's living space. Luminous,

Chromodoris nudibranchs
(CHROMODORIS WILLANI)
**Lembeh Strait,
Sulawesi, Indonesia**

rainbow-colored jellies, starlike planktonic creatures, giant squid, translucent prawns, gray dolphins, brown lizards, spotted giraffes, emerald mosses, rustling grasses, every leaf on every tree and all people everywhere, even residents of inland cities and deserts who may never see the sea, are nonetheless dependent upon it.

All things considered, it seems so reasonable that people **should** care about the oceans and **should** be driven by a sense of urgency about knowing more. An aquatic atmosphere covers most of the planet's surface, encompasses the continents, and provides a home for most of life on Earth, yet it remains for humankind inaccessible and unknown, by and large ignored, overlooked, or simply taken for granted. How is this possible?

Although many individuals are aware of pollution problems, declining stocks of fish, and pressures on populations of dolphins and whales, for most people, concern for the state of the oceans is **not** a high priority. This may be related to the widely held view that the ocean is so vast and resilient that there is little reason to worry, either about what is put **in** or about what is taken **out** of our oceans.

But two centuries ago, there were no 40-mile-long drift nets sweeping through the open sea, indiscriminately taking everything in their path, from targeted tuna to fragile jellyfish, turtles, and even whales.

False anemonefish
(AMPHIPRIOIN OCELLARIS)
**Kimbe Bay,
Papua New Guinea**

There were no mega-trawlers scraping entire ecosystems into their giant maws, no acoustic fish finders, no factory ships for processing catches at sea, no global marketing and distribution systems that make possible the appearance in Tokyo restaurants of creatures still living, though taken from half a world away.

This is a time of pivotal, magnified significance for humankind. Our actions are accelerating a global warming trend that will have profound consequences. The fabric of life and the physical and chemical nature of the planet have been significantly altered through decisions already made by our predecessors and those now living; what happens next depends on what we do, or do not do, individually and collectively, in the next few decades.

Like small, exuberant children entranced with myriad bright lights and colored wires on a giant computer, we tug and twist and pull without the faintest idea of the consequences to the machinery—or to ourselves. It is now with a sense of urgency that I encourage everyone to use whatever talents and resources are available to continue to explore and understand the nature of this extraordinary ocean planet— as depicted so beautifully in the colorful images and captivating creatures of OCEAN DUETS.

Sylvia A Earle

My fascination with marine creatures did not begin at an early age. It was only after I made a career move that took me from California to Florida in 1984 that I became intrigued with the abundant life-forms beneath the sea. In California, I was a die-hard sports fanatic who lived to snow ski high **above** sea level. Little did I know that the warm tropical waters off the Florida Keys would eventually bring a lifetime of fulfillment and happiness—far **below** sea level.

Settling in Florida, I traded skis for flippers and became scuba certified. I needed a physical outlet that would replace skiing when I was not working in the high-stress world of corporate real estate. Once certified, it took just a heartbeat to realize that I could pursue my interest in photography—by taking photographs underwater. With a camera in hand and a regulator in my mouth, I became totally consumed with diving and discovering the delightful creatures that inhabit our seas.

Corporate life did put a positive spin on my ability to go diving. It gave me the financial ability to purchase equipment, and business travel racked up plenty of frequent-flyer miles so that I could go diving in exotic locations. With the reefs of Florida in my backyard, I honed my diving and underwater photography skills. Every free minute away from the office was spent learning about photography and researching new locations to explore.

Michele diving in Tahiti

PHOTO © STUART WESTMORLAND

While photographing subjects, a passionate photographer will always look at new ways to view things. That's when the creative juices really start to flow. I knew I eventually wanted to produce a portfolio that was different from the norm, and ultimately a book. But I wanted my book to be fun and not just a compilation of images. When I noticed I was seeing "two of a kind" in much of my imagery, it dawned on me that here was an adorable concept in the making: shooting pairs beneath Noah's Ark. How many marine pairs could I find? Where would I find them? This gave me a new challenge.

The waters of the Indo-Pacific Region, particularly Papua New Guinea, harbor not just schooling fish and colorful coral reefs, but fascinating marine life buried in the sand. I've spent hours there, hovering just above the sand and rubble, searching for animals. The creatures that live in this once-overlooked and seemingly impoverished "muck" habitat are truly captivating. Not only do they show interesting behavior and biology, but they range in appearance from the beautiful to the bizarre.

On one such bottom dive in about 20 feet of water, I could see across the sand for 30 yards or more. Peeking out of hundreds of small holes scattered across the seafloor were hundreds of tiny fish that glimmered in my

headlight like brilliant nuggets of gold. They were yellow shrimp gobies (Cryptocentrus cinctus) *on alert at the entrance to their burrows, ready to retreat at the first sign of danger.*

I was eager to get a closer look. Resting on the bottom, I controlled my breathing as I slowly inched my way closer to a burrow. Each breath and release of expelled air bubbles made the timid residents vanish into the safety of their homes.

Patience paid off. After many painstaking minutes of creeping across the sand, I was finally within shooting range with my camera just as a goby reappeared at its burrow entrance. As I watched this shimmering little fish, I was delighted to see yet another goby suddenly pop out of the burrow to rest alongside its mate. The delicate pair perched there at the entrance to their coveted real estate, a tiny burrow dwarfed against the vastness of the Pacific Ocean.

What I discovered next was even more surprising: the gobies were not the sole proprietors of their burrow. A pair of blind pistol shrimp (Alpheus *sp.*) *also appeared at the entrance, pushing rock and debris out of the burrow, just like miniature bulldozers. I had not one, but two pairs to photograph as I watched what turned out to be a fascinating symbiotic relationship unfold between fish and shrimp.*

One of the funniest things that happened to me while

Yellow shrimp gobies
(CRYPTOCENTRUS CINCTUS)
and blind pistol shrimp
(ALPHEUS SP.)
**Kimbe Bay,
Papua New Guinea**

A double pairing of fish and shrimp seem unlikely roommates, yet these odd couples share symbiotic burrow duties. The gobies act as "watch fish," guarding the burrow and their blind cohabitants, while the bulldozing pistol shrimp remove debris and keep the entrance clean. With at least one long antenna in physical contact with a goby at all times, the shrimp use sudden fish movements as their cue to scurry back into their tiny burrow.

**INSET
Striped gobies**
(GOBIOSOMA SP.)
**on purple sponge
Florida Keys,
Florida**

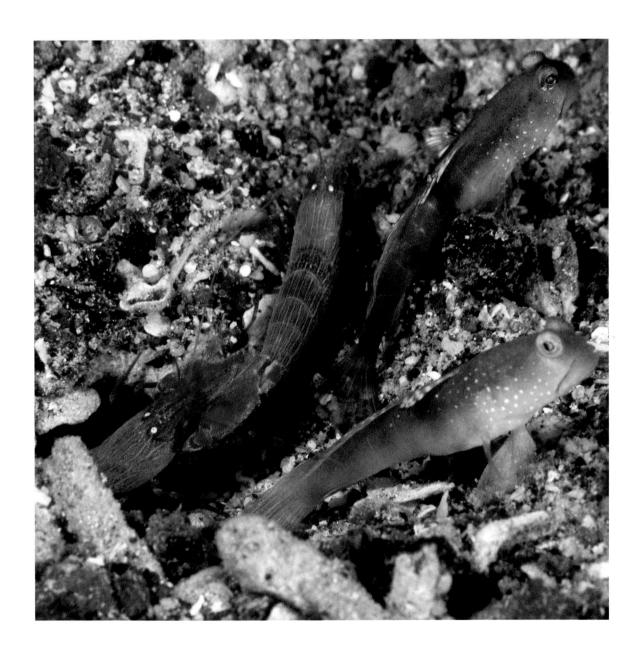

photographing pairs occurred when I was diving the Intracoastal Waterway in Florida. Not only did I look through discarded household items, guns, and knives, but animal parts as well. I was searching for some of the wonderful critters that inhabit this underwater junk-yard when I came across a pair of goat legs! No carcass, just the legs. I learned later that the Jamaican and Bahamian communities eat a lot of goat meat. Some-times they slaughter the goats and discard the unused body parts in the waterway. The result is a feeding bonanza for a variety of interesting fish that gather to pick at the flesh—a nice little treat for them.

As you look at the photographs in OCEAN DUETS, keep in mind that there is an interesting story behind each image. Nothing is as easy as it appears, and the effort required to capture each of the photographs in this book was often as humorous as it was painstaking. For example, I flew to the Big Island of Hawaii thinking I could quickly shoot a turtle duet for the book. I know of several locations where green or hawksbill turtles usually line up to be cleaned by various fish. So I headed to one of those locations.

My camera was already loaded with film. All I had to do was to gear up and jump in. Barely 15 feet under-water, I heard the dreaded, telltale beeping from my housing that warned of a broken seal. One look in the dome port and the dive was over. A water leak had turned my new lens and camera into a very expensive paperweight. Even after I acquired new gear, I only saw one turtle during my weeklong trip—but plenty of cleaner fish.

Developing the concept of OCEAN DUETS further, I began to study animal behavior in order to improve my ability to spot subjects. It was then that I discovered the bonds between wonderful species.

There are many types of pairs in the ocean, not just breeding pairs. There are mother-baby pairs, female pairs, and juvenile pairs that come together simply to play, and there are symbiotic relationships that form between different species. My research taught me to look in the tiniest of crevices, to carefully inspect a color-ful sponge-covered rock, or the arms of a delicate sea fan gently swaying in the current. What at first looks like an inanimate object often turns out to be an animal (or two) so well camou-flaged as to nearly be overlooked.

In contrast, photography of large marine life requires one to move the fastest. From manta rays to humpback whales, I have to be prepared to enter the water quickly, with my camera system ready. This doesn't mean making a huge splash while entering the water from the boat. A little stealth is required. Gently slipping into the water, then moving quickly with long, smooth, kicking strokes is a must—

Green sea turtle
(CHELONIA MYDAS)
with cleaner fish
Kona, Hawaii

along with controlled breathing. Any movement that looks threatening will alarm the animals, and your photo opportunity will vanish.

Patience is an absolute necessity in any kind of wildlife photography. But underwater photographers have an additional challenge: time limits. The depth and amount of air in your tanks will determine whether you get the image or not. On a dive in Papua New Guinea, I desperately wanted a picture of two pygmy sea horses near each other on a small sea fan. The problem was, I had already been in the water some 10 minutes and I was now at 94 feet, with my guide pointing at the two tiny creatures.

Pygmy sea horses are camera shy, and my reluctant subjects repeatedly turned away from the camera. I had to wait until I could get their eyes in focus. This is extremely difficult when the animals are the size of your thumbnail. I got only two good frames before I had to begin retreating to the surface. My dive computer was beeping, signaling that I was in a decompression dive, and my tanks were registering very low. After making the slowest ascent possible, I alerted the boat's crew to drop another tank over the side so that I could spend a little more time decompressing at 20 feet. This is a situation experienced divers would never get themselves into, but photographers are known to push the limits.

Pygmy sea horse

(HIPPOCAMPUS BARGIBANTI)

Papua New Guinea

I have had many memorable underwater experiences while shooting for OCEAN DUETS. It is difficult to pick a favorite, but my experience diving with humpback whales is definitely at the top. The sheer size of these magnificent mammals is quite a thrill, but even more incredible was having a baby whale come right up to me to check out the strange-looking creature in neoprene. Another time, I was in the water with a male humpback that floated head down while singing his song of love to attract a female. My entire body vibrated from the low-frequency sounds made by the huge animal as I remained motionless just below the surface of the water in complete and utter fascination.

It has taken more than six years to collect enough images of pairs to complete OCEAN DUETS, and I am still looking for more. Much of the time, I have been simply lucky; but often, the hours I spent reading material on marine life and their captivating, often secretive behavior provided me with valuable clues in my search for the ultimate couples.

Enjoy. May these beautiful creatures entertain as well as inspire you to remember the fragility of our rich marine heritage.

Michele Westmorland

P.S. Just before going to press, I finally got my coveted shot of a turtle pair!

Orange anemonefish

(AMPHIPRION SANDARACINOS)

in Marten's anemone

(STICHODACTYLUS MERTENSII)

Papua New Guinea

Spinecheek anemonefish

(PREMNAS BIACULEATUS)

in bulb tentacle anemone

(ENTACMAEA QUADRICOLOR)

Papua New Guinea

Of the nearly 30 known species of anemonefish, orange anemonefish are one of the more difficult to locate in the wild. Also called clownfish because of their bright coloration and, at times, comical movements, anemonefish rely on chemical camouflage to avoid being stung by their host. By producing a mucous coating that chemically matches the one covering the anemone, the fish prevent the nematocysts from firing as they swim, feed, and sleep among the anemones' feeding tentacles.

Sea anemones, corals, and jellyfish are all simple animals that belong to the same group, *Cnidaria*, the "stingers"— so named for their specialized weaponry. Like upside-down jellies, anemones attach to the substrate with their crown of tentacles facing upward. They use their stinging cells and tentacles to snare any edibles that might drift by—shrimp, prawns, and small fish—which are then passed via the central mouth into the stomach.

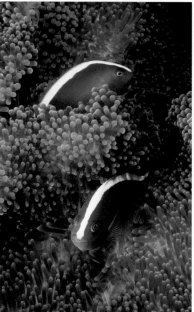

This duet of spinecheek anemonefish nestles amid a profusion of long, bulb-tipped tentacles. Named for the prominent backward spine visible on each gill, these feisty fish are aggressive toward all intruders, including members of their own species. Their darting, territorial behavior serves to protect their delicate invertebrate host from predation while attracting food in the way of other small fish. In return, the anemones' stinging cells help to keep the fish and their eggs equally safe from hungry enemies.

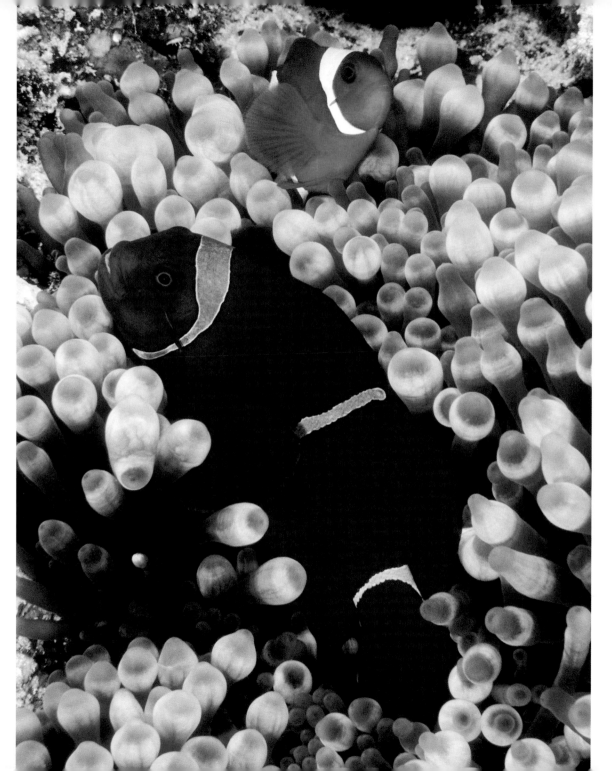

Orangefin anemonefish
(AMPHIPRION CHRYSOPTERUS)
Papua New Guinea

These were the very first clownfish I ever photographed, and it is one of my earliest underwater images. By the time I went to Papua New Guinea in 1991, I was already passionate about my underwater photography. In fact, it was the first time I used my new housed underwater camera system. This image remains one of my favorites. Years later, during an editing session, this photograph sparked the idea for OCEAN DUETS.
—*M. W.*

Pink anemonefish
(AMPHIPRION PERIDERAION)
on anemone
(HETERACTIS MAGNIFICA)
Papua New Guinea

A pair of pink clownfish floats above the vivid purple mantle of their host anemone. The protection provided by the anemone is essential for clownfish, as they are poor swimmers and would quickly perish in open water. Clownfish have an interesting reproductive system: they are protandrous hermaphrodites—they all mature as males and then sex-reverse to females as needed. The largest fish in the group is always the female. Should she die, the largest male then changes into a female to replace her.

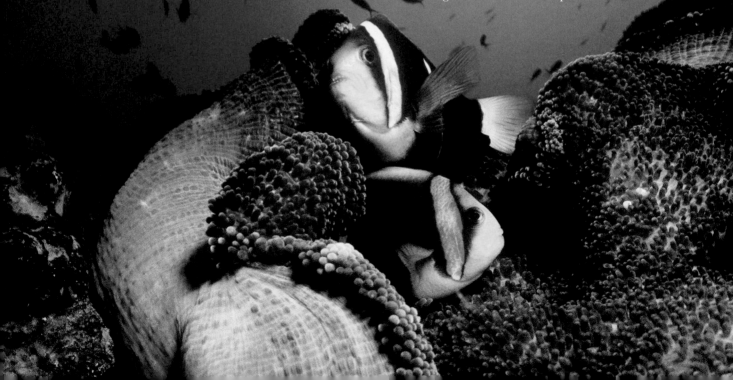

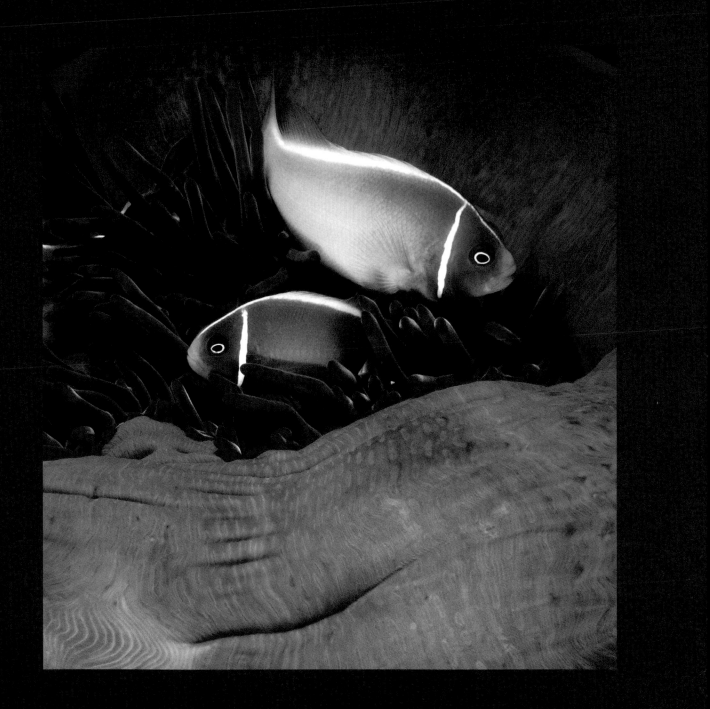

Bottlenose dolphins

(TURSIOPS TRUNCATUS)

**Republic of Palau,
Micronesia**

Bottlenose dolphins

(TURSIOPS TRUNCATUS)

**Republic of Palau,
Micronesia**

These tactile, playful, highly social animals are the most agile, active, and sexual of marine mammals, mating throughout the year. Bottlenose dolphins communicate with each other using whistles, grunts, clicks, and pings, as well as other sonic and ultrasonic sounds. They locate their prey by sonar, similar to the echolocation used by flying bats.

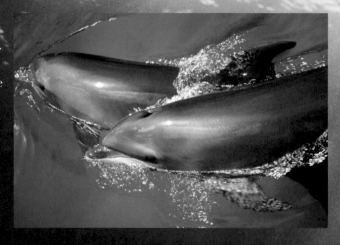

BACKGROUND

Atlantic spotted dolphins

(STENELLA FRONTALIS)

Bahamas

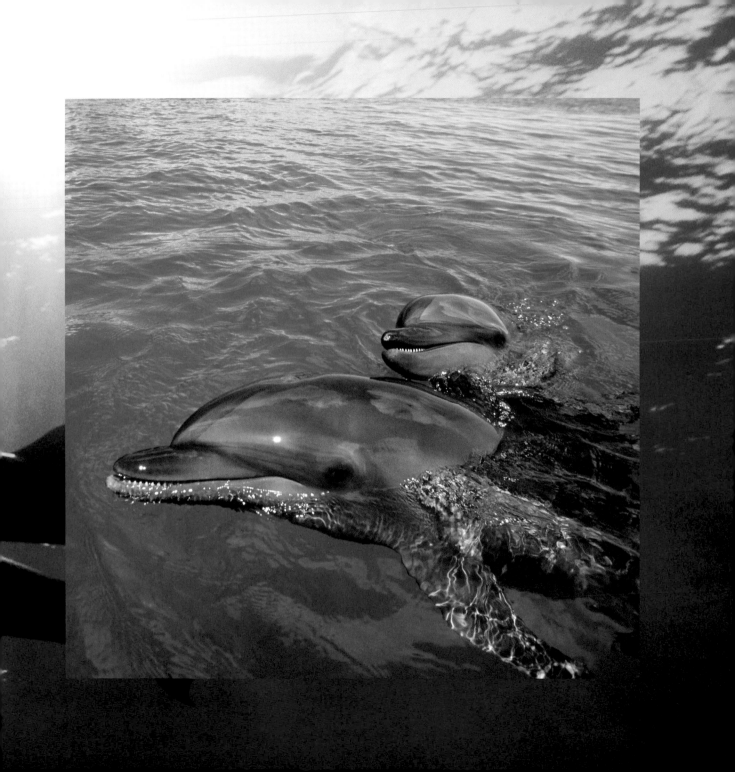

Atlantic spotted dolphins

(STENELLA FRONTALIS)

**White Sand Ridge,
Bahamas**

Spinner dolphins

(STENELLA LONGIROSTRIS)

**The Fathers,
Papua New Guinea**

Atlantic spotted dolphins are fast, active swimmers, often seen leaping out of the water and falling back to the surface with a big splash. This acrobatic behavior can occur when they are feeding, in pursuit of fish and squid, but also just for fun. Unspotted at birth, these inquisitive mammals are as talkative as they are social. Water is the perfect medium to carry their loquacious vocalizations over great distances.

A pair of spinner dolphins is photographed joy-riding bow waves in Papua New Guinea. Named for their high, spinning leaps, these agile, free-spirited marine mammals produce quite a repertoire of "whistling" underwater calls. In fact, at times, their playful vocalizations can sound eerily like those made by a diver's leaking air cylinder.

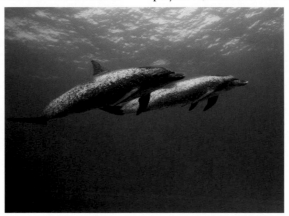

I've had some incredible encounters with spotted dolphins while diving in the Bahamas—with a couple of dolphin groups that like to interact with people. I watched one dolphin tirelessly play with a scarf that a diver had handed to it. Most memorable was a mother who came up close to show me her calf. Dolphins are beautiful, trusting, and intelligent animals. Their joie de vivre is contagious.
—M. W.

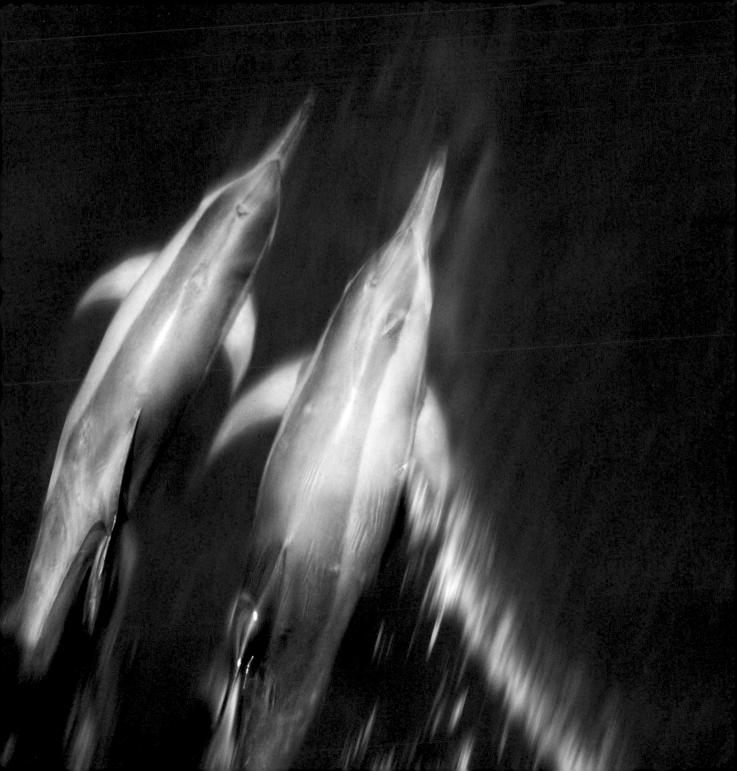

White-tipped reef sharks
(TRIAENODON OBESUS)
Malpelo Island, Colombia

I had the extraordinary experience of diving with more than 50 white-tipped reef sharks off Malpelo Island. There were so many of them that they literally kept bumping into me. White-tipped reef sharks are primarily night hunters that aggressively forage the coral reefs. Contrary to popular belief, all sharks do not need to keep swimming in order to breathe, as this cartilaginous pair demonstrates by resting on the bottom.

—M. W.

Silky sharks
(CARCHARHINUS FALCIFORMIS)
Socorro Island, Mexico

Found in the Atlantic, Pacific, and Indian Oceans, silky sharks prefer warm water ranging from the surface to depths of 1,550 feet or more. These large, slender predators can grow up to 10 feet in length, with the males slightly smaller than females. Like lions, tigers, and wolves on land, sharks play an important role in maintaining the health of their ecosystem. These awesome ancient predators deserve protection, not persecution.

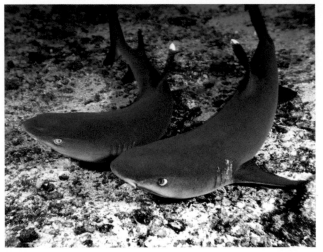

Located some 300 miles from Cabo San Lucas, Socorro is a remote diving area famous for large-animal encounters. Great numbers of silky sharks come into this territory. One day, while hanging onto the anchor line below our dive boat, I could see numerous silky sharks in the distance. Curiosity got the best of them, and they came closer and closer. Soon a large number of the sharks were circling me, checking me out, and occasionally bumping into me. This behavior red-flagged a potentially dangerous situation from which I quickly exited.

—M. W.

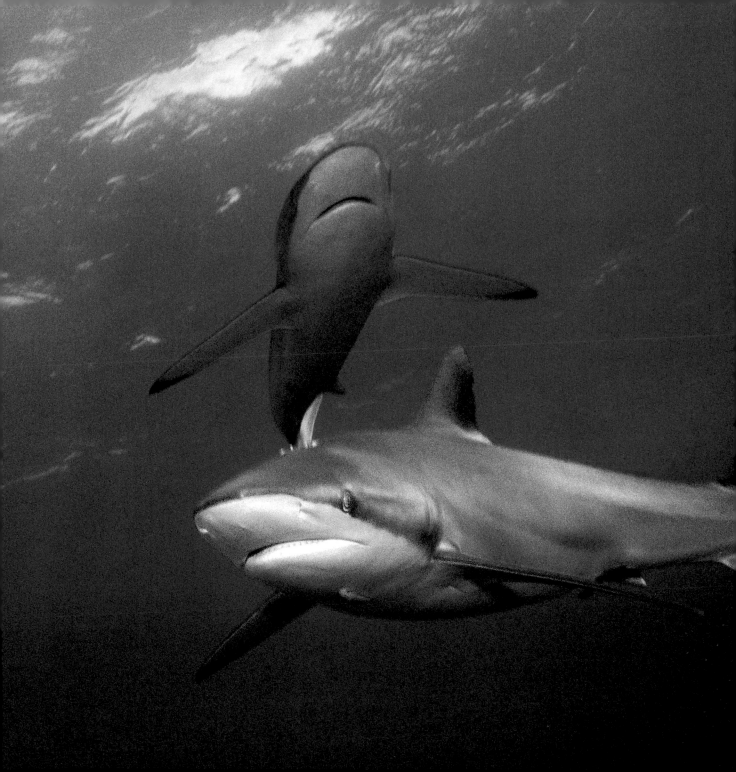

Cleaner shrimp

(PERICLIMENES BREVICARPALIS)

on anemone

Papua New Guinea

Anemone shrimp

(PLIOPONTONIA FURTIVA)

Lembeh Strait,

Sulawesi, Indonesia

The concept of habitat is interesting in a marine environment. It can be as large as a reef or a sunken ship, as expansive as the sandy bottom, or simply as small as the side of a fish. In the case of cleaner shrimp, habitat can mean the single anemone on which they reside, protected from predators by the anemone's toxic tentacles. Called the "janitors" of the reef, cleaner shrimp clean every living surface possible, including fish, anemones, and the occasional diver.

Notice the tremendous size difference between the large female and the smaller, nearly invisible male; this is one of the more exaggerated examples of sexual dimorphism among cleaner shrimp. Native to reefs of the Indo-Pacific, where they are usually found on disc anemones, these delicate decapods visually confuse predators with their transparent oval bodies marked with distinctive white and yellow bands and spots.

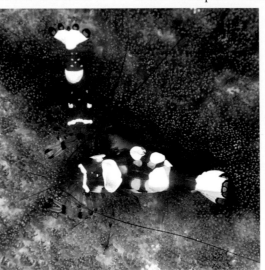

In order to find tiny shrimp like these, I had to look for a very long
time at a small area of a reef. Floating there for several minutes,
I focused my eyes to watch for the slightest movement.
Only then was it possible to see one of the little critters crawl
to the end of a tentacle to feed on microscopic specks of algae.
—M. W.

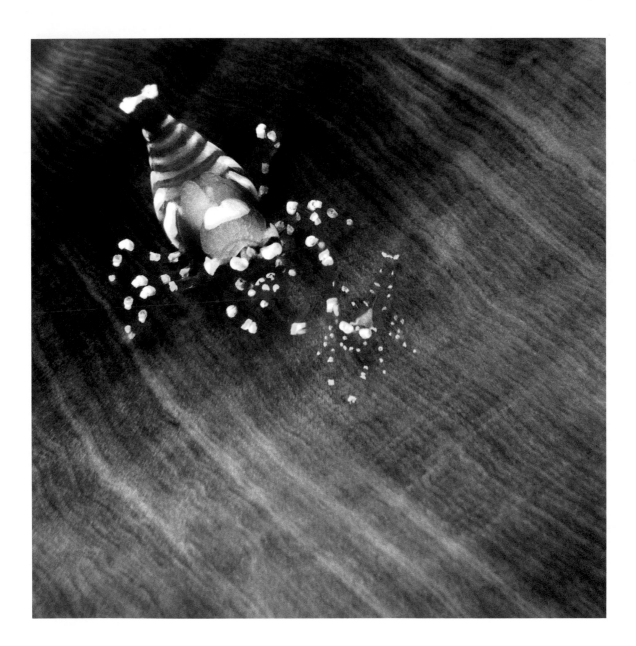

Nus shrimp

(PHYLLOGNATHIA CERATOPTHALMUS)

Lembeh Strait,
Sulawesi, Indonesia

Cleaner shrimp

(PERICLIMENES KOROENSIS)

Bali,
Indonesia

Why search for extraterrestrial life in deep space when "aliens" such as these inhabit our planet? Ressembling extras from a sci-fi film, nus shrimp are a species only recently discovered and named. This tiny shrimp duet was photographed resting on coral-encrusted bivalves. Covered with red spots, each spot outlined with even tinier purple and black polka dots, they are living art.

Cleaner shrimp, also called anemone shrimp, are fascinating, beautifully camouflaged animals that exist in an amazing variety of colors and patterns that they can alter to match their hosts. The long chelipeds and white heads help identify this pair; the blue eggs indicate gender. This species is frequently found resting on mushroom coral, as seen here.

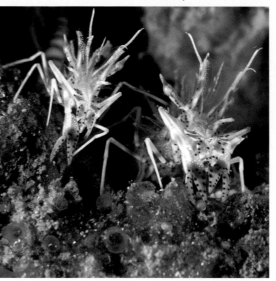

I discovered this delicate pair of cleaner shrimp by gently lifting the edge of a mushroom coral that was lying on the sandy substrate. Shaped like a round loaf of bread, the coral was covered on top with short tentacles and had a smooth concave underside—the perfect hiding place for this comical twosome. I was thrilled to see that one of the shrimp had a belly full of eggs.
—M. W.

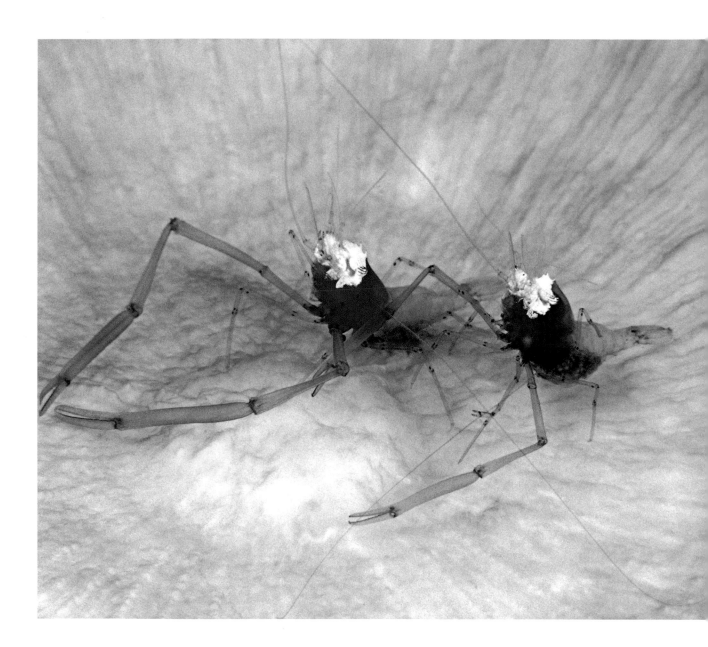

Golden coral shrimp

(STENOPUS SCUTELLATUS)

Intracoastal Waterway, Florida

Anemone shrimp

(PERICLIMENES BREVICARPALIS)

Missool, West Papua

Golden coral shrimp occur singly or as mated pairs. They are also called "boxing shrimp," because their pincers are set back on their third set of legs and when threatened, they hold up their barber-pole-colored dukes, ready to fight. Anatomically different from other shrimp, these banded beauties belong to a separate genus all to themselves.

With transparent bodies covered in uneven white blotches, claws and legs with blue joints, and tails that end in five black eyespots with orange centers, these anemone shrimp look psychedelic. Yet they are effectively using disruptive patterns and colors to visually camouflage the outlines of their bodies from predators.

The Intracoastal Waterway is a nursery for many juvenile species.
It is probably the most unlikely place that people would think
of to scuba dive, yet it is a treasure chest of amazing
little creatures waiting to be discovered.
—M. W.

Emperor shrimp

(PERICLIMENES IMPERATOR)

on sea cucumber

Lembeh Strait,

Sulawesi,

Indonesia

Emperor shrimp

(PERICLIMENES IMPERATOR)

on sea cucumber

(BOHADSCHIA ARGUS)

Lembeh Strait, Sulawesi,

Indonesia

Looking for a pair of emperor shrimp is like searching for Waldo in the popular book series—they come in a variety of sizes and colors, yet one is lucky to find a single pair once on every 50 to 100 sea cucumbers. The shrimp like to hide along the undersides of their huge hosts, using them like "meals on wheels" to travel over the substrate in search of food. Divers have to be careful not to expose the tiny decapods, as predatory cardinal fish often use divers to help them locate their prey.

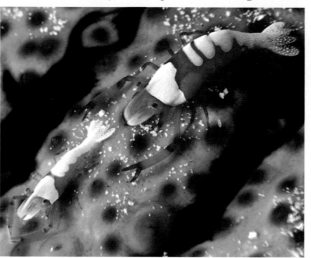

This duet of shrimp, with wild, purple-tipped pincers, is resting on a sea cucumber. Their mobile platform belongs to an echinoderm with a fossil record that dates back 400 million years. When threatened, some sea cucumbers expel sticky body parts to distract, even entangle, would-be predators. The lost tissue is then regenerated.

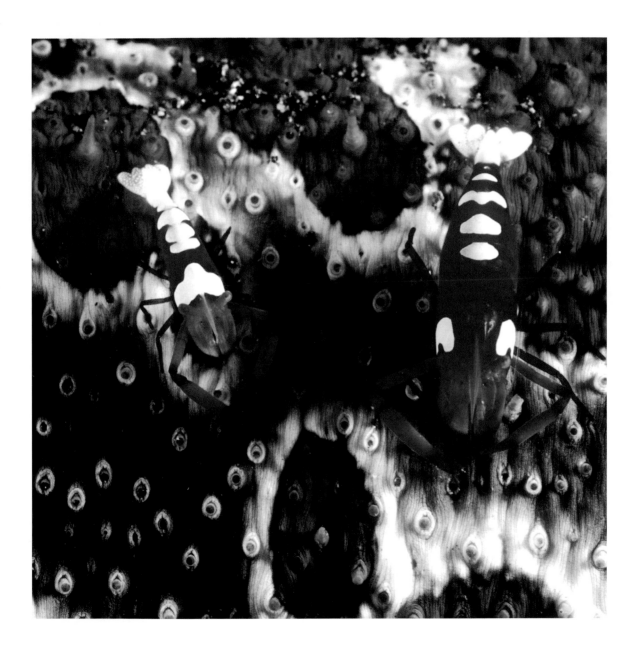

Cleaner shrimp

(PERICLIMENES VENUSTUS)

on anemone

Bali, Indonesia

Pink clownfish

(AMPHIPRION PERIDERAION)

giant anenome

(HETERACTIS MAGNIFICA)

and cleaner shrimp

(PERICLIMENES HOLTHUISI)

Kimbe Bay,

Papua New Guinea

Perfectly camouflaged against their invertebrate host, a pair of see-through cleaner shrimp disappears into an anemone backdrop of white-tipped tentacles. These small, swimming crustaceans are omnivorous scavengers, so named because they feed on parasites, algae, and dead tissue.

The clownfish, cleaner shrimp, and giant anemone share a symbiotic relationship—they help each other survive. The anemone, or host, protects the smaller, homesteading symbionts. In return, the cleaner shrimp obtain food by grooming both the fish and anemone. The clownfish also obtain food and keep the host clean by eating the anemone's fish and invertebrate leftovers. In addition, the territorial movements of the clownfish help increase water (oxygen) circulation around the anemone while protecting it from polyp-eating fish.

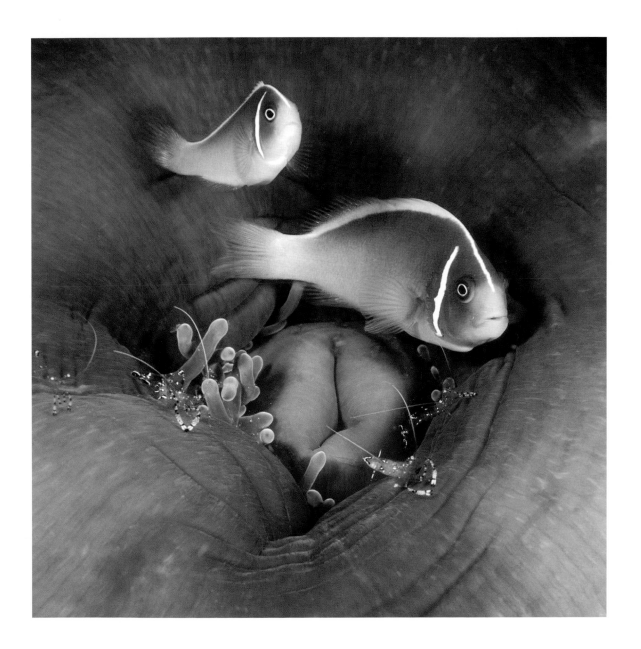

Coleman shrimp

(PERICLIMENES COLEMANI)

and fire urchin

(ASTHENOSOMA VARIUM)

Milne Bay,

Papua New Guinea

A pair of Coleman shrimp rests cryptically amid a kaleidoscopic field of shape and color that even an artist would find hard to reproduce. The tiny hitch-hikers live safely in the furrows between the fire urchin's deadly spines, often cleaning off an area on which to perch.

Warning predators to stay away with a visual explosion of color and pattern, the fire urchin is one of the most dramatic examples of art in nature. Yet for all its beauty, it is definitely a reef creature to avoid. The highly mobile urchin is covered with bulb-tipped spines, each with its own venom sac. Upon contact, the venom is injected, causing intensely painful wounds that can hurt for hours.

In an area of about 50 square feet, I found an equal number of fire urchins. While inspecting them for tiny crabs or shrimp, I inadvertently touched a fire urchin spine—or two. The pain inflicted by the venomous spines lasted for hours and only diminished as the poison dissipated.
—M. W.

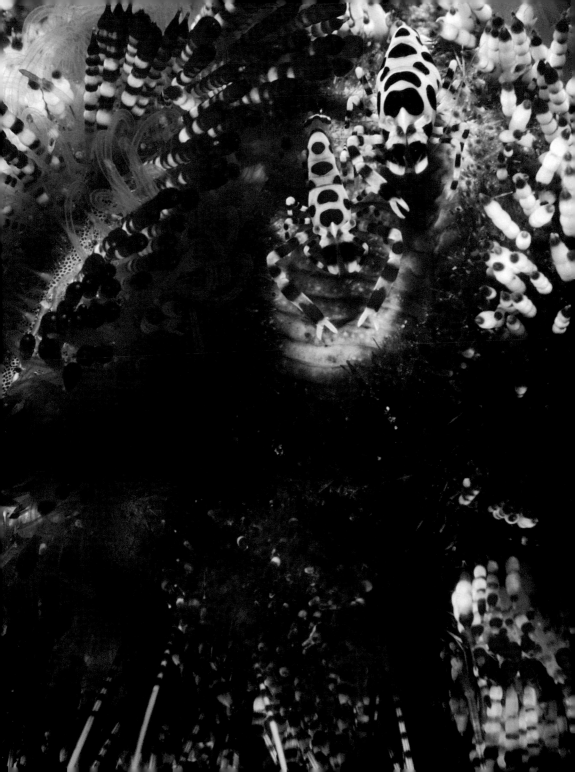

Obicular crabs
(LISSOCARCINUS ORBICULARIS)
on a sea cucumber
(BOHADSCHIA MARMORATA)
Lembeh Strait,
Sulawesi, Indonesia

So perfectly camouflaged is this tiny crab against the dazzling sea cucumber background that it is almost impossible to see. The little crabs roam and feed like spotted ghosts over their symbiotic host, helping to keep the sea cucumber clean as they hitch a ride. When threatened, the cryptic crustaceans quickly scurry for shelter, often taking refuge in the mouth of the sea cucumber.

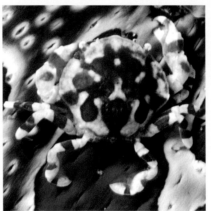

Amazing little creatures such as this crab and cucumber combo inhabit the otherwise drab sand-and-rubble seafloors now routinely explored during popular "muck dives." In fact, Lembeh Strait in Sulawesi, Indonesia, is considered the muck-diving capital of the world, where two dive resorts are conveniently located on the shores of a protected marine preserve.

I had already learned that sea cucumbers often host different species.
By carefully observing animals that slowly crawl along the sandy bottom,
I knew that I might be able to discover a miniature world. Even so, I was
surprised when the dots on the sea cucumber suddenly began moving—
two very well camouflaged crabs hitching a slow-motion ride to nowhere.
—M. W.

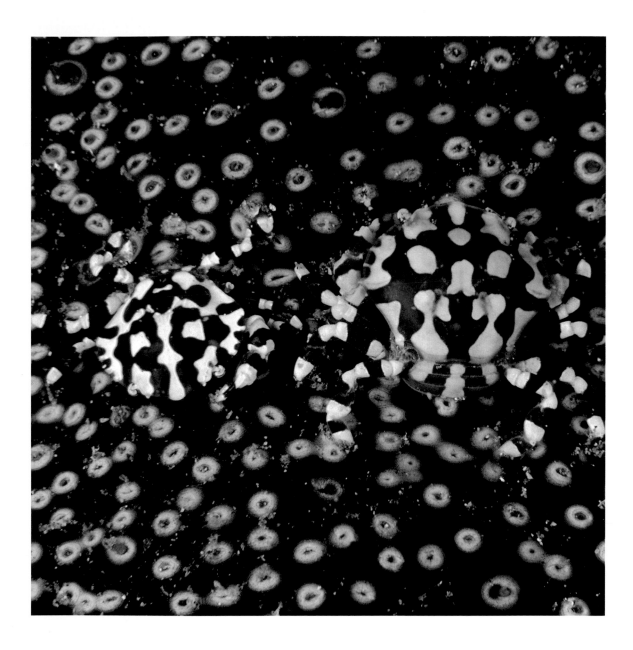

Soft coral crabs

(HOPLOPHRYS OATESSI)

and soft coral

(DENDRONEPHTHYA SP.)

Indonesia

Soft coral crabs are some of the most difficult crabs to find and photograph, because they so closely mimic the texture and color of their gorgonian backgrounds. The color match is achieved by the crabs feeding on the polyps of their colonial host. These tiny coral mimics literally disappear against the pinks, purples, yellows, and oranges of the soft corals they inhabit—and eat.

Banded clinging crabs

(MITHRAX CINCTIMANUS))

Bahamas

Typically shy, banded clinging crabs inhabit coral reefs usually in association with anemones. Like all true crabs, they are equipped with five pairs of legs, four for walking with the fifth pair modified into well-developed claws used to gather food, move objects, and for defense. These sensitive crustaceans are loaded with receptors to monitor their aquatic environment, including stalked, compound eyes for excellent vision, bristles and hairs to detect water currents and touch, and antenna and mouthparts that respond to chemical stimuli. Not only do crabs hear well, but they can also produce a variety of sounds—by banging their pincers on the ground and vibrating their legs.

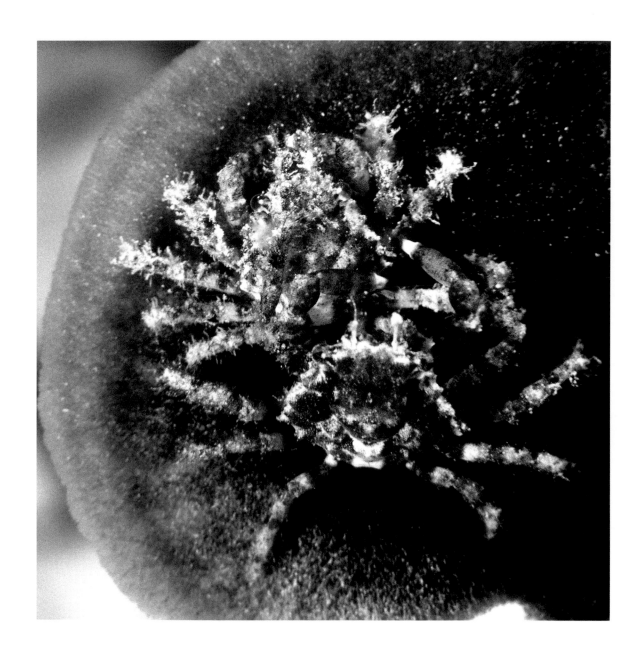

Clark's anemonefish

(AMPHIPRION CLARKII)

and porcelain crabs

(NEOPETROLISTHES OHSHIMAI)

on anemone

South Coast, New Britain,

Papua New Guinea

Zebra crabs

(ZEBRIDA ADAMSII)

on fire urchin

(ASTROPYGA RADIATA)

Lembeh Strait,

Sulawesi, Indonesia

Able to walk over the nematocyst surface of their host without ill effect, a pair of porcelain, or anemone, crabs rests in close association with a pair of Clark's anemonefish. The crabs feed on plankton caught in lattice-like structures attached to the two appendages folded beneath their mouths. These delicate structures are raised like sails into the current when the crabs are actively feeding.

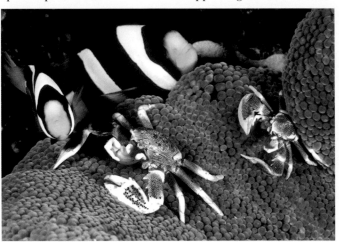

Illustrating the underwater magic of marine biology, where one life-form grows upon another, often disappearing with a trick of the eye, a pair of tiny zebra crabs lives autonomously within the micro-cosm of a fire urchin. The last segment of each hind leg is shaped into a hook, making it possible for the hitchhiking crabs to hold on to the spines of their mobile hosts.

It's just delightful to find a double pair.
The close association of the clownfish and crabs with their
sea anemone host made this special photograph possible.
—M. W.

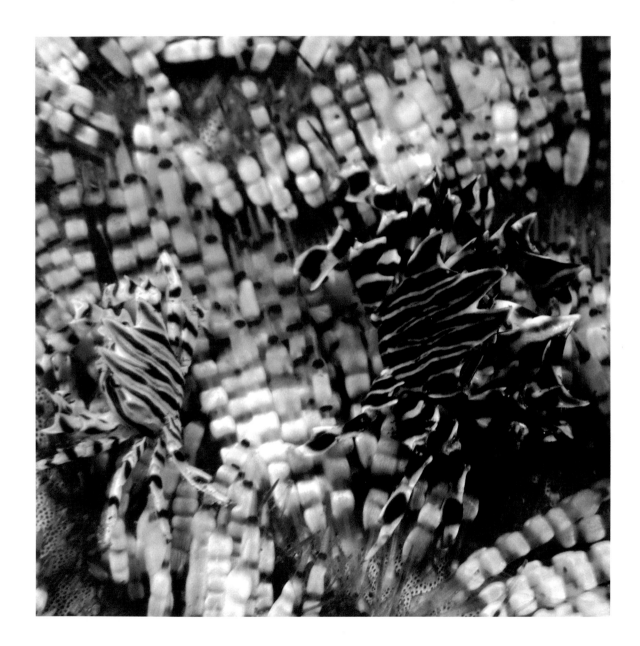

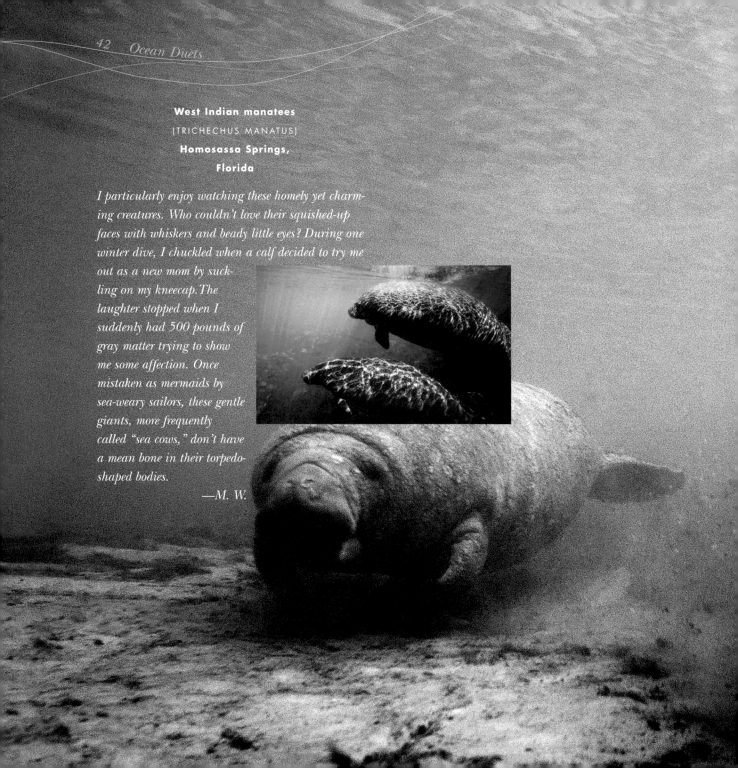

West Indian manatees

(TRICHECHUS MANATUS)

**Homosassa Springs,
Florida**

I particularly enjoy watching these homely yet charming creatures. Who couldn't love their squished-up faces with whiskers and beady little eyes? During one winter dive, I chuckled when a calf decided to try me out as a new mom by suckling on my kneecap. The laughter stopped when I suddenly had 500 pounds of gray matter trying to show me some affection. Once mistaken as mermaids by sea-weary sailors, these gentle giants, more frequently called "sea cows," don't have a mean bone in their torpedo-shaped bodies.

—M. W.

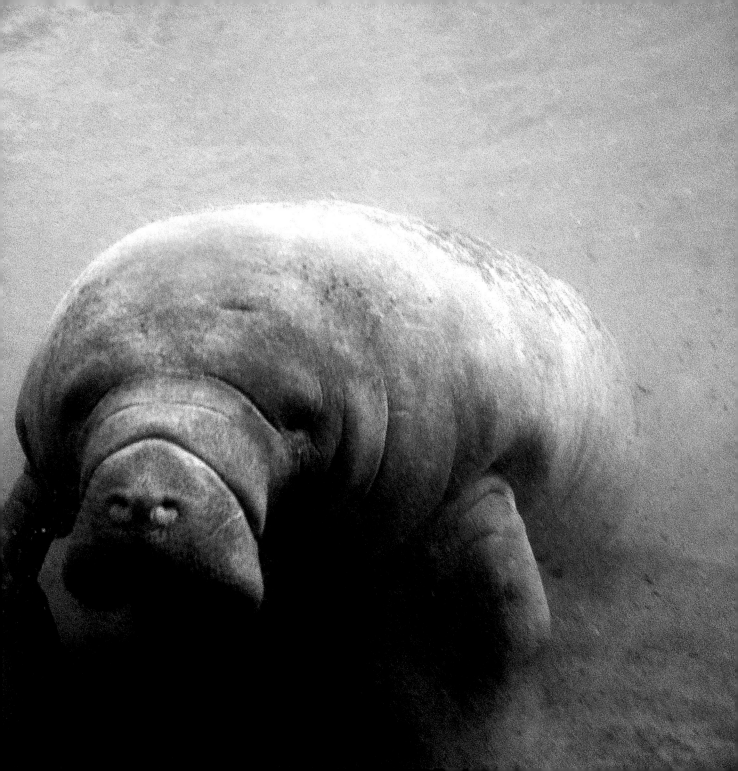

Chromodorid nudibranchs

(CHROMODORIS KUNIEI)

**Lembeh Strait,
Sulawesi, Indonesia**

Chromodorid nudibranchs

(CHROMODORIS ANNAE)

**Lembeh Strait,
Sulawesi, Indonesia**

Outlined in neon purple, a pair of chromodorid nudibranchs mates in a stunning display of frills and color, the female larger than the male. Essentially snails without shells, nudibranchs are some of the most beautiful animals that live in the ocean. Adorned with bouquets of feathery external gills, these boldly colored creatures often move about during the day, unafraid of predators.

Like arrow poison frogs and monarch butterflies, these soft-bodied mollusks use brilliant colors to warn would-be predators to stay away. Sea slugs may look easy to catch and good to eat, but by feeding on sponges and sea anemones, some species are loaded with borrowed toxins, even unfired nematocysts. Their eye-catching colors send a strong message to experienced predators: *Don't touch! We taste bad!*

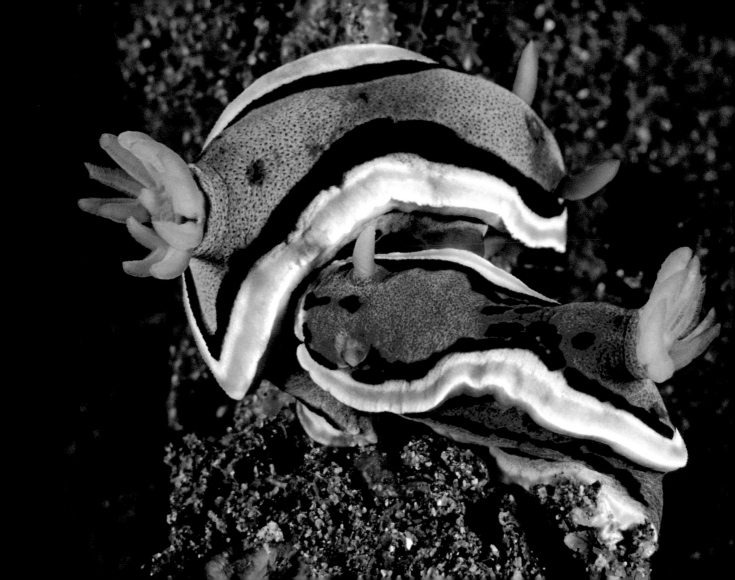

Nembrotha nudibranchs

(NEMBROTHA RUTILANS)

**Lembeh Strait,
Sulawesi, Indonesia**

Nembrotha nudibranchs

(NEMBROTHA KUBARYANA)

**Kimbe Bay,
Papua New Guinea**

Considered the underwater analogues of butterflies, nudibranchs come in intriguing shapes and colors, here a distinctive purple, rust, and white. Notice the flowerlike dorsal gills and the pair of chemosensory antennae on their heads, which are used to locate food and mates. These amorous sea slugs are mating in a colorful display of reef passion. Each individual increases its chance to reproduce by being equipped with both male and female sex organs.

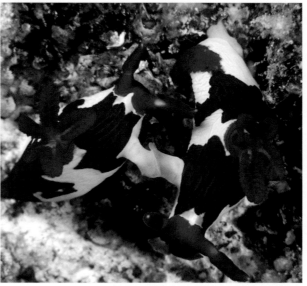

Nembrotha nudibranchs are known for their awesome colors, strange shapes, and frilly external gills, seen here as if blooming from the middle of their backs. In fact, the word *nudibranch* means "naked gills." This exotic couple crawls over the substrate in search of food. Equipped with a row of tiny teeth, the grazing carnivores dine on anything that moves slower than they do, including anemones, corals, tunicates, and sponges, and sometimes even other sea slugs.

Nudibranchs

(CHELIDONURA VARIANS)

Witus,
Papua New Guinea

Nudibranchs

(PTERAEOLIDIA IANTHINA)

Kimbe Bay,
Papua New Guinea

Gliding across the sand at top speed, this Darth Vader–like pair moves surprisingly fast. Their anatomy makes this possible. Classified as a marine gastropod, a sea slug is basically a stomach on a broad, muscular foot. More mobile without shells, some species can even swim. A graphic artist would be hard pressed to come up with a more beautiful design.

These delicate, pencil-thin sea slugs are commonly called blue dragons because of their striking resemblance to the ceremonial Chinese dragons. Lacking gills, their bodies are covered in a fringe of tubular growths called cerata. These long respiratory structures not only increase the surface area for dissolved oxygen absorption, but also contain parts of the nudibranchs' digestive systems. Blue dragons utilize solar power as an alternative energy source—they farm microscopic plants in their cerata that convert sunlight into sugars.

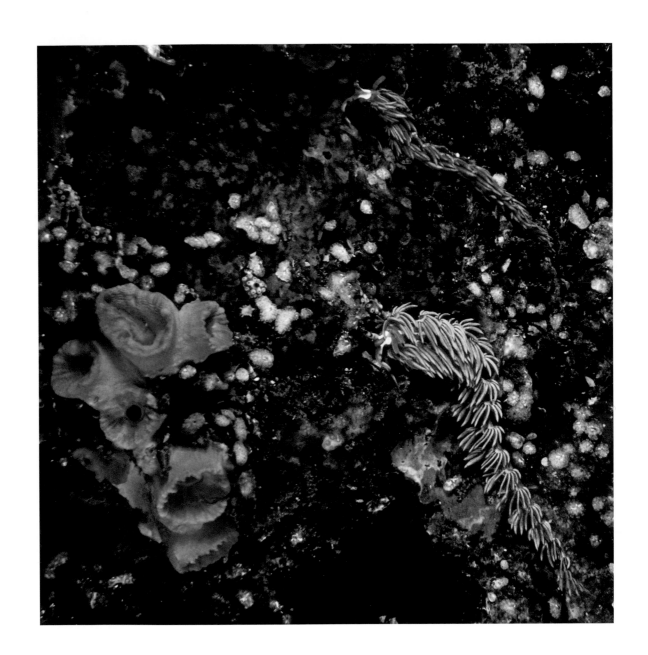

Nudibranchs

(DISCODORIS BOHOLIENSIS)

**Lembeh Strait,
Sulawesi, Indonesia**

Photographed with an underwater strobe, this species is quite visible against the black volcanic sand; however, without such artificial light, the cryptic creatures would quickly disappear in the darkness. The saying "you are what you eat" applies to nudibranchs, as they often acquire the colors of the food they ingest. In addition to using camouflage and chemical warfare to discourage predators, many nudibranchs go one step further—they shed regenerative body parts when under attack.

Nembrotha nudibranchs

(NEMBROTHA KUBARYANA)

on a sea squirt

(POLYCARPA AURATA)

**Marovo Lagoon,
Solomon Islands**

Coupled in the process of mating, a pair of sea slugs joins their polka-dotted bodies on the side of a sea squirt, or tunicate. These multitasking mollusks appear to be mating and munching at the same time, as tunicates are one of their preferred foods. Designed to strain plankton and organic particles from the water, sea squirts enjoy a brief free-swimming larval stage before attaching to the substrate, where they mature and remain for the rest of their lives—unable to escape the unwanted attention of grazing, copulating nudibranchs.

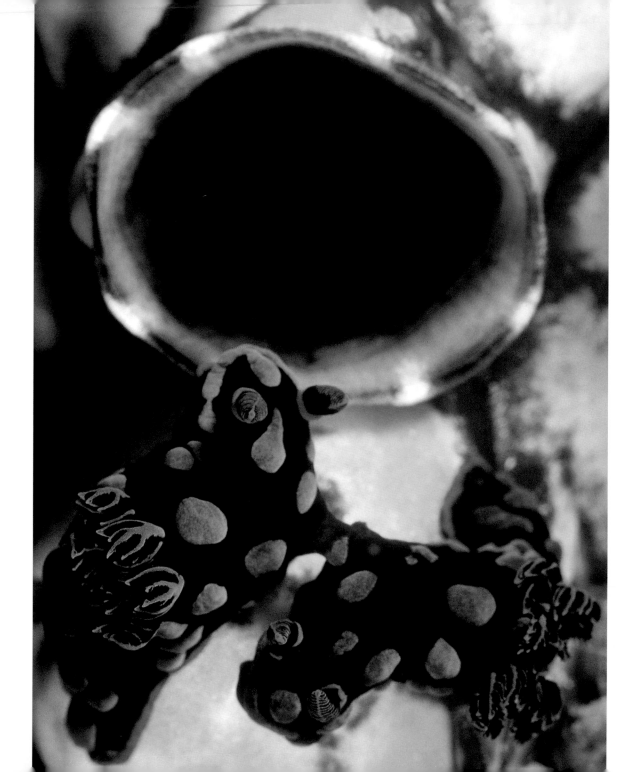

Blue-spotted flounders

(BOTHUS OCELLATUS)

Florida Keys, Florida

Blue-ribbon eels

(RHINOMURAENA QUAESITA)

Lembeh Strait, Sulawesi, Indonesia

Humorous to watch, a male flounder romantically pursues a little female. Larval flounders begin life as normal, bilaterally shaped fish. However, before taking up their flattened adult life on the seafloor, one eye migrates across the head until it settles next to the other, swim bladders disappear, bellies lighten, and a lone pectoral fin extends from the center of their backs. Their stalked periscopic eyes are often all that is exposed above the sand when flounders hide from predators.

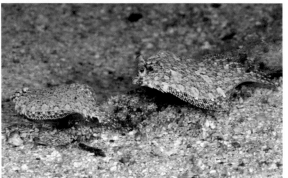

Creatures in the sea are wonderfully diverse, as illustrated by this colorful pair of blue-ribbon eels. In fact, there are more kinds of animals in the sea than on land. Much of this diversity is dependent on the health of coral reefs—like wondrous marine rain forests —that encircle the equatorial belly of the planet. Yet despite their life-sustaining importance, less than 5 percent of the world's oceans have been explored. From deep canyons and spewing volcanic vents to dark and mysterious seafloors that lie miles below the surface—with 40,000 miles of undersea mountain ranges to explore—a world of discovery awaits future aquanauts.

This is one of my favorite photos. The juvenile eels start out jet black with yellow stripes. Retaining their bright stripes, the eels turn an electric blue about the time they reach a half meter in length. They all mature as males, not females. Only when it is time to mate do some of the eels undergo a sex change. After two males pair up, one eel gradually changes color from bright blue to greenish yellow as it transforms itself from male to female.

—M. W.

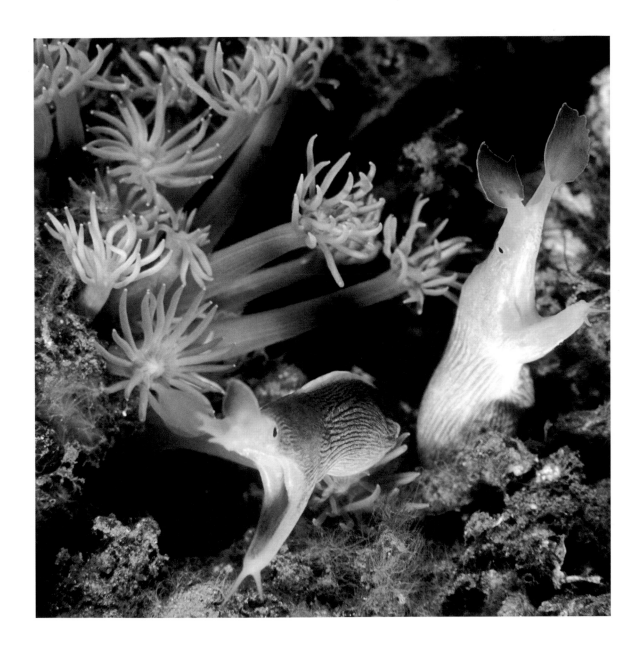

personalities.

I once had a memorable encounter with a moray eel while diving 240 miles off the coast of Colombia. Malpelo Island is a wild, wild diving area with few anchorages and very strong currents. The reef was covered with urchins, and every nook and cranny had a moray eel in it. While taking a photograph of the reef area, I didn't pay attention to my buoyancy and I sank down dangerously close to the reef. All of a sudden, I felt teeth. When I looked down through my viewfinder, there was a moray eel clamped onto my left thigh. Luckily, I was wearing a thick wet suit and the eel quickly let go, as morays often bite and hang on. The encounter left tiny teeth marks in my leg.
—M. W.

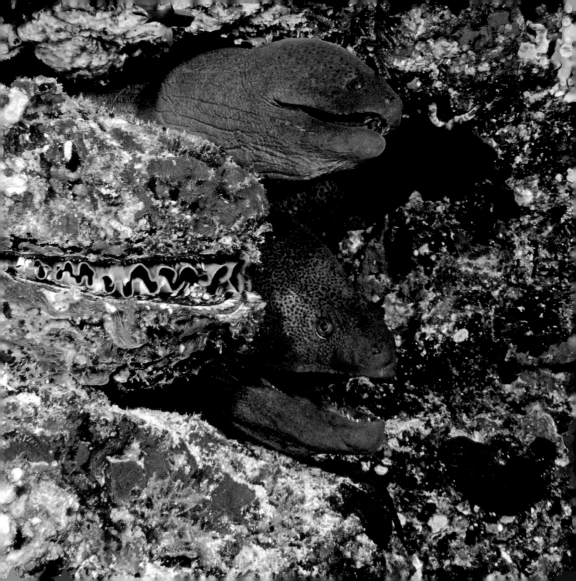

Long-nosed hawkfish
(OXYCIRRHITIES TYPUS)
Kimbe Bay,
Papua New Guinea

Camouflaged in a gorgonian sea fan, a pair of long-nosed hawkfish waits for dinner to pass. Named for their predatory habits and pointed "beaks," hawkfish perch on sponge and coral-head lookouts, then swoop down on small unsuspecting fish and crustaceans that come within range. Lacking swim bladders, hawkfish are negatively buoyant, which enables them to launch their split-second attacks. In between meals, their otherwise sedentary behavior—holding onto coral branches with the thickened rays of their pectoral fins—makes them an ideal photo subject.

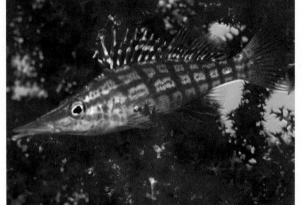

Although brightly colored, this pair of hawkfish relies on camouflage to survive. Just ten meters below the surface creatures with red or pink pigments are the first to "disappear," as most of the red and yellow light waves from the sun are absorbed near the surface. Light waves at the far blue end of the spectrum penetrate farther, but very little light reaches depths beyond 1,000 feet. Most of the ocean is, in fact, deep and dark.

This romantic image in Valentine colors was taken during an important moment in my own personal life: I had traveled to Papua New Guinea to get married. Stuart and I had just exchanged vows on a beach while wearing tribal dress. The following day while diving, I discovered this hawkfish pair tucked under a coral branch—a nice wedding gift!
—M. W.

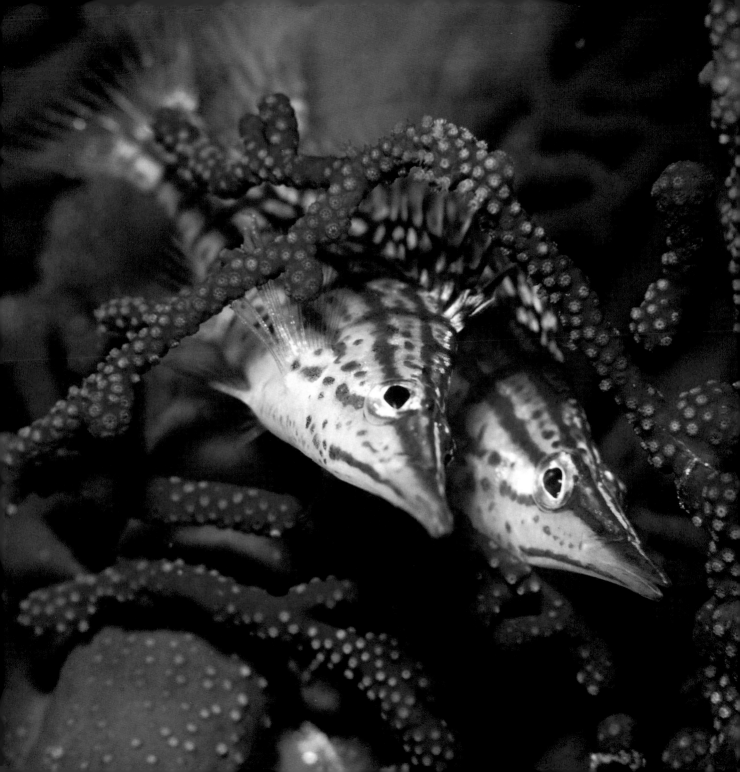

Coral groupers

(CEPHALOPHOLIS MINIATA)

Milne Bay,
Papua New Guinea

Covered with bright-blue spots on an orange-red background, coral groupers can be found hiding in caves and under reef ledges in the tropical waters of the Indo-Pacific. They have to hide, because their vivid colors make them a popular catch in the pet trade and fishermen pursue them as "coral cod" for the dinner table. Feeding on fish and invertebrates, the groupers stop short when it comes to cleaner shrimp. The tiny crustaceans can often be seen crawling over the omnivorous fish, even inside their open mouths.

Pygmy sea horses

(HIPPOCAMPUS BARGIBANTI)

and coral fan

(MURICELLA PLECTANA)

Kimbe Bay,
Papua New Guinea

Not much bigger than a thumbnail, and only discovered in the past few years, pygmy sea horses are the tiniest known sea horses in the world. The bulbous tubercles that cover their bodies and tails match the polyp structures of the gorgonian host on which they live. It takes a magnifying glass to find these cryptic miniatures because of their small size and perfect camouflage among the soft coral.

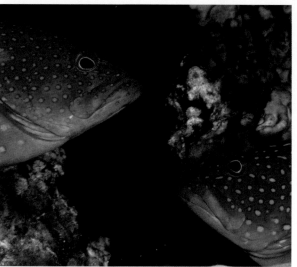

Most groupers are nondescript mottled brown,
not such a beautiful shade of magenta. It is sad to imagine
such a jeweled fish served on a dinner plate, but that is
exactly where many of these striking fish end up—
as popular dishes on local menus.
—M. W.

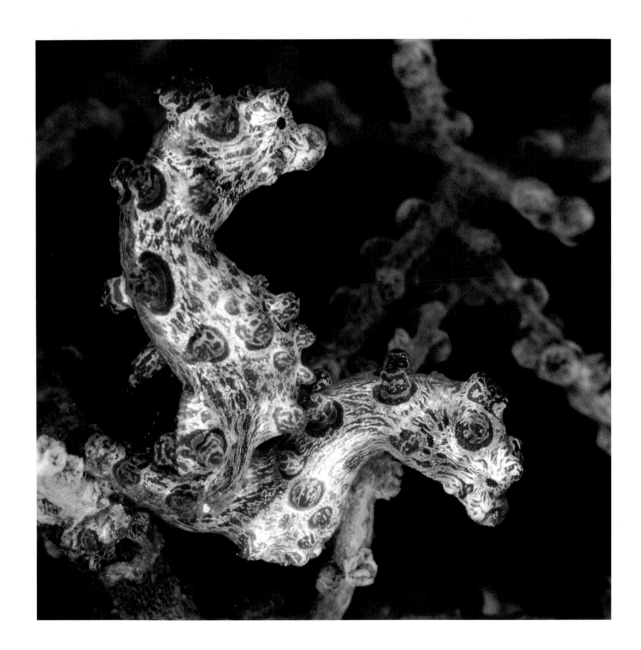

Lined sea horses

(HIPPOCAMPUS ERECTUS)

Intracoastal Waterway,
Florida

Equipped with gills, fins, a swim bladder, and eyes that move independently, like those of a chameleon, sea horses are actually bony fish. They use their prehensile tails to hold onto coral and seaweed, relying on camouflage to survive. The ancient Greeks gave them mythical attributes, describing them as sea monsters (*campus*) with the head of a horse (*hippos*).

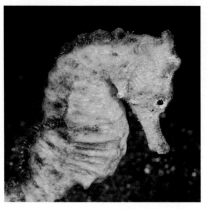

These ambush predators suck in their tiny prey with their long, tubular mouths. During courtship, the monogamous pair pivots, promenades along the bottom, changes color, and finally rises to the surface to mate. The eggs are fertilized and protected inside the male's brood pouch. Once hatched, the miniature sea horses are off to the races, highly vulnerable to predation.

Looking like something from a fairy tale, sea horses are some
of the most beloved creatures in the marine environment.
Yet it is the sea horse male, not female, that carries the
offspring until they are mature enough to be expelled from
his pouch into the open water to fend for themselves.
—M. W.

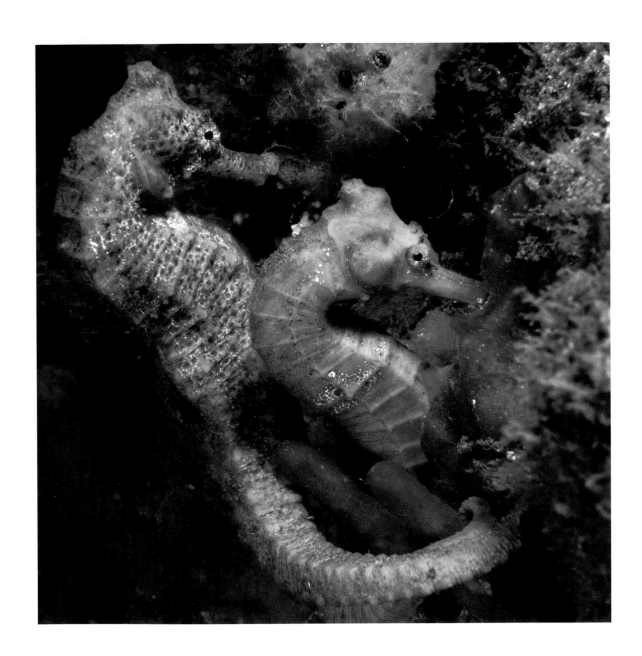

Mandarin fish

(SYNCHIROPUS SPLENDIDUS)

Republic of Palau,
Micronesia

A pair of mandarin fish gets cozy as they "perch" on the rocky bottom using their pectoral fins. Showing sexual dimorphism, the male is always larger than the female, with longer fins and an elongated dorsal fin. Popular among divers due to their spiraling courtship "dance" and brilliant colors, mandarin fish feed on crustaceans and other benthic organisms. These adorable fish are native to the western Pacific, found living at depths between 1 and 18 meters.

Named for the brightly colored silk robes worn by the Mandarin Chinese in the 19th century, these ornate, slow-moving fish pack a huge visual wallop for their small size. A popular species among aquarists, many mandarin fish perish each year in captivity due to their very specialized eating habits.

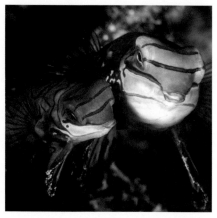

To me, mandarin fish couples are one of the most romantic in the sea.
These beautifully colored fish only mate at dawn and dusk, for approximately a
half hour during the brief twilight periods. The male goes in search of females,
attracting them by displaying his brightly colored pectoral and dorsal fins,
much like a peacock shakes his iridescent tail feathers in front of a peahen.
Once the mandarin male succeeds in attracting a mate, the pair rises up three
to four feet in the water column, where they spawn in a cloud of milt before
quickly darting back into the drab seafloor rubble from which they emerged.
—M. W.

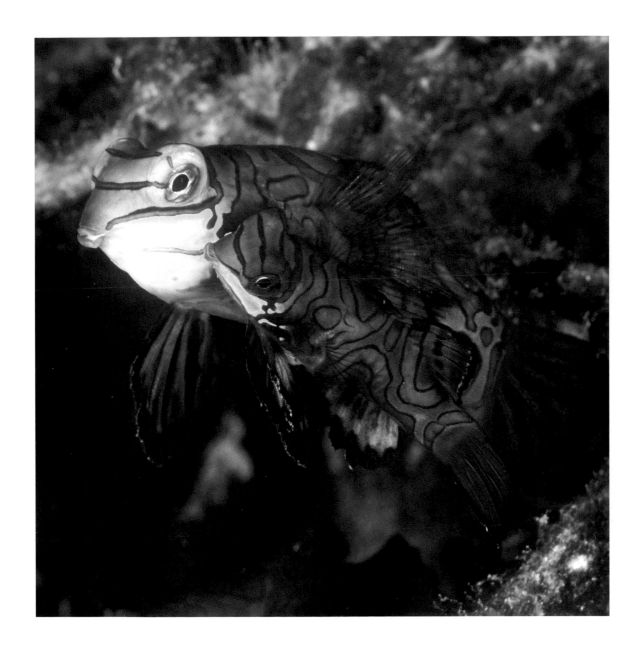

Masked bannerfish

(HENIOCHUS MONOCEROS)

and hard coral

(ACROPORA SP.)

Kimbe Bay,

Papua New Guinea

A pair of masked bannerfish floats beneath a protective stand of hard coral in the clear waters of Kimbe Bay. Many species of fish are closely associated with particular types of corals for food, shelter, and as a place to lay and protect their eggs. Described as the architects of the reef, hard corals play a vital role in maintaining marine biodiversity. Without them, many marine organisms would be homeless and hungry.

Longfin bannerfish

(HENIOCHUS ACUMINATUS)

Milne Bay,

Papua New Guinea

Seeking cover among a grove of soft corals, a pair of longfin bannerfish displays their elongated, tapering dorsal filaments. While juveniles are usually solitary, the adults typically occur in pairs. Feeding on zooplankton and bottom-dwelling invertebrates, these beautiful relatives of the butterflyfish inhabit sheltered coastal bays and lagoons at depths ranging from 2 to 75 meters.

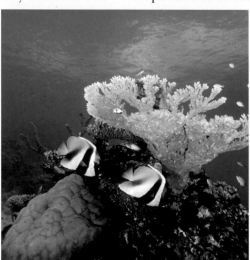

Milne Bay is famous as a rich site for stunning marine macrophotography. By way of contrast, I decided to pull back with a larger exposure and look at the bigger picture. What I discovered was this beautiful pair of bannerfish swimming gracefully among the large gorgonian sea fans.
—M. W.

Giant mantas

(MANTA BIROSTRIS)

Islas Revillagigedo, Mexico

Adorned with hitchhiking remoras, a pair of mantas glides through the water on giant pectoral "wings," their graceful movements made possible by flexible, cartilaginous skeletons. With wingspans measuring up to six meters or more, giant mantas are definitely a sight to behold, whether encountered at the ocean's surface or in deep blue water. Related to sharks, rays are ancient creatures that have been swimming the seas for millions of years.

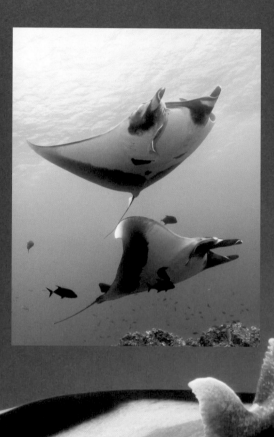

Southern stingrays
(DASYATIS AMERICANA)
Stingray City,
Cayman Islands

Marbled rays
(TAENIURA MEYENI)
Cocos Island,
Costa Rica

A pair of southern stingrays "flies" over their preferred habitat, shallow coastal areas with sandy bottoms. Avoiding walls and reef structures that make it difficult to feed, these opportunistic scavengers graze day and night along the bottom, relying on touch, electroreception, and a strong sense of smell to find and capture their unsuspecting prey.

Filmed for the opening sequence of *Jurassic Park*, Cocos Island is as intriguing beneath the surface as its jungle habitats are above. Marbled rays and hundreds of schooling hammerhead sharks gather here each year to breed. Marbled ray courtship can be rough on the female, who is often pursued by as many as 15 amorous suitors.

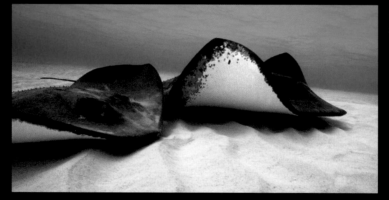

Stingray City, a small sandy-bottomed area in the Cayman Islands, is one of the most popular tourist attractions in the world. Here, divers and nondivers alike can swim with southern stingrays that are so habituated to people, they will take squid right out of your hands. The rays use a powerful sucking motion to draw in their food. I've felt them sucking the top of my head before I even saw the five-foot rays, so eager were they to get a free handout.
—M. W.

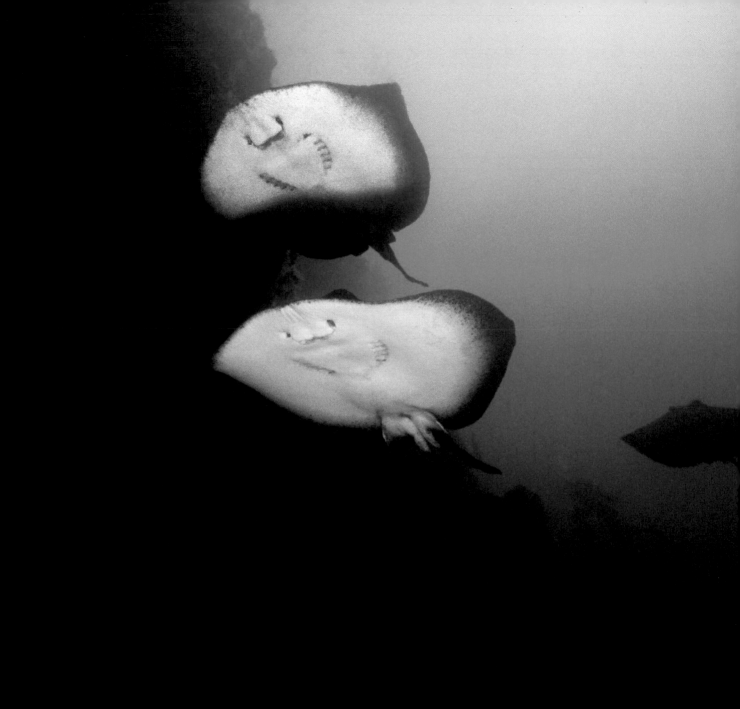

Cowries

(FAMILY CYPRAEIDAE)

Indonesia

These thumb-size treasures were discovered feeding on a coral head. Typical of cowries, they have extended their soft mantles to conceal their hard shells beneath. Called "gems of the sea" due to their glossy, beautifully patterned shells, cowries range in size from 7 millimeters to 19 centimeters in length. Popular among shell collectors, cowries have served as currency in Africa, been worn by royalty in the Pacific Islands, and are still used today to decorate the clothing and artifacts of many cultures.

Sea squirts

(POLYCARPA AURATA)

and tunicates

(RHOPALAEA CRASSA)

Papua New Guinea

The subphylum *Tunicata* contains about 1,600 species of tunicates, commonly know as sea squirts. This animal group is of particular interest to evolutionary biologists, because as larvae, tunicates reveal a chordate heritage with a well-developed notochord, propulsive tail, an eye with a lens, and a dorsal-tubular nerve cord that ends in a brain. All of these structural traits are lost during metamorphosis into sessile, seawater-siphoning adults, yet they hint at vertebrate ancestry.

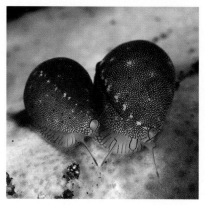

Purple and yellow sea squirts are quite common in Papua New Guinea. What caught my eye was the way these two species were nestled together, both filter feeders, in an artistic arrangement of pattern, color—and siphons.
—M. W.

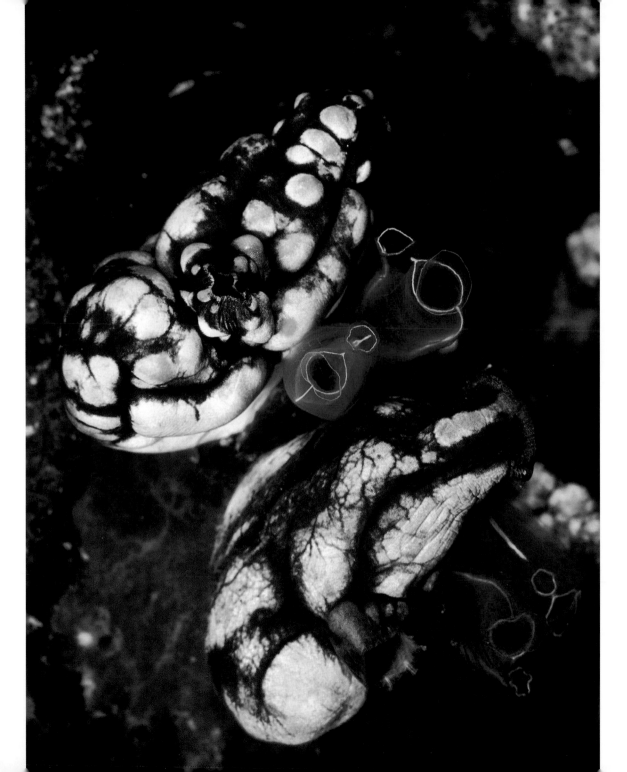

Lettuce sea slugs
(TRIDACHIA CRISPATA)
Florida Keys,
Florida

Striated frogfish
(ANTENNARIUS STRIATUS)
Intracoastal Waterway,
South Florida

Covered with skin flaps and ruffles, these algae impersonators have evolved to look like the reef plants on which they feed. They, too, rely on solar power for go-power, stealing chloroplasts from the green algae they eat and then farming them to convert sunlight into sugars and nutrients. Commonly found in the calm water areas of the Bahamas, Caribbean, and Florida, lettuce sea slugs rely on camouflage to fool their predators. If disturbed, these tricky photosynthesizing mollusks can produce noxious defensive secretions.

The bottom of Florida's Intracoastal Waterway seems an unlikely place to find such an exotic pair, except that the salty waterway is also home to sea horses, hairy blennies, and pancake batfish. Complete with frills and fishing lures, frogfish rely on deceptive camouflage to ambush their prey. These lunge-and-gulp predators walk along the bottom on pectoral "feet" rather than swim. The lighter-colored females are more aggressive than the males.

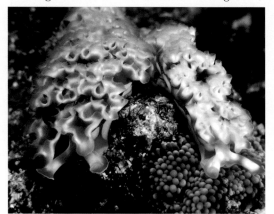

There are numerous species of frogfish. The striated species is probably one of the most interesting because of all the frills and appendages that help it look weedy. They literally disappear into their habitat. I like their grumpy look and the funny way they walk.
—M. W.

Tasseled scorpionfish

(SCORPAENOPSIS OXYCEPHALA)

Malpelo Island, Hugo's Rock, Colombia

So perfectly disguised are tasseled scorpionfish that species that normally feed on coralline algae often approach to pick at their lurelike dermal flaps. This is a deadly mistake, as these sit-and-wait predators can lunge and gulp so fast that unsuspecting fish are down the hatch before they even know what happened. Scorpionfish often enhance their disguise by resting on soft corals that match the fringe around their concealed mouths.

These were the largest scorpionfish I have ever seen. They easily measured 2.5 to 3 feet long and weighed at least 20 pounds. But everything grows big here.

It takes 40 hours to reach Malpelo Island off the coast of Colombia. Then you dive 70 feet down to reach the top of a pinnacle. It was the roughest, wildest place to dive I've ever been, but the marine life was spectacular because of Malpelo's isolation in the middle of the eastern Pacific. It definitely is an underwater wonderland, but it is a very dangerous place to dive, as I almost brought my husband back in a body bag. At a depth of 45 feet, he was suddenly sucked farther down, into a deep cave, by an unexpected surge. He completely disappeared and I feared the worst. Missing a fin and a strobe from his camera system, he survived after being violently forced through a rear cave exit that instantly ejected him 70 feet to the surface.

—M. W.

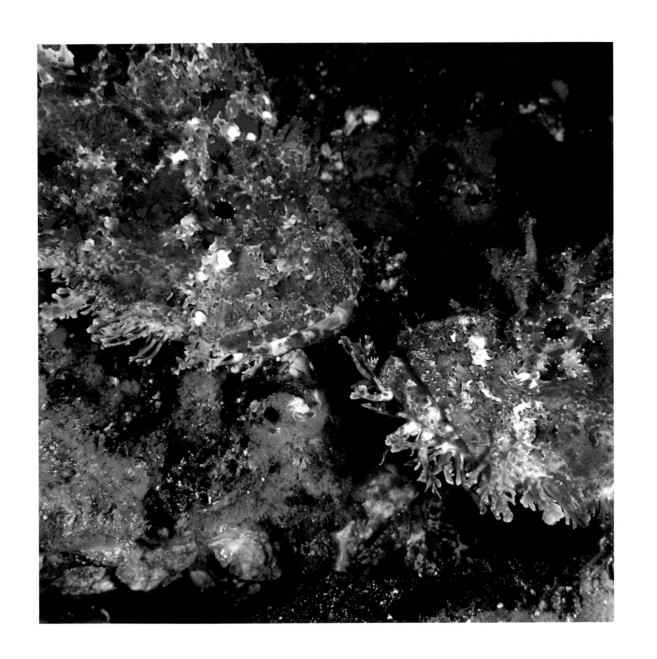

Leaf scorpionfish

(TAENIANOTUS TRIACANTHUS)

Big Island, Hawaii

Pictured here like a red and white Valentine, this cryptic species can be a heartbreaker if one encounters the venomous dorsal spines. Camouflage artists extraordinaire, they are called leaf fish for a reason. Like debris being gently rocked back and forth in a current, leaf scorpionfish are superb plant mimics that intentionally sway from side to side to enhance their disguise.

Tasseled scorpionfish

(SCORPAENOPSIS OXYCEPHALA)

Papua New Guinea

Not the prettiest fish in the sea, these stealthy predators with tasseled beards are well camouflaged against the coral reef. Covered with coral-like flaps and fringe, these ambush predators use visual deception to hide from both predators and prey. Should this deception fail, they are armed with venomous spines guaranteed to leave a lasting impression, especially on unwary divers.

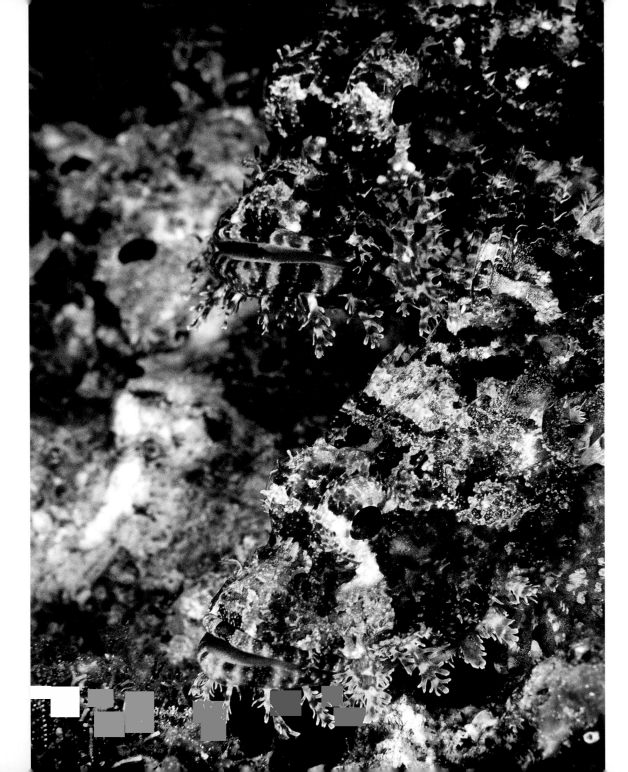

Orangefin anemonefish
(AMPHIPRION CHRYSOPTERUS)
Kimbe Bay,
Papua New Guinea

A pair of orangefin anemonefish guards their cluster of golden eggs in a coral crevice. Resembling a blue shag carpet, their colonial host provides further protection against intruders. Each polyp is armed with a stinging cell, ready to fire. Orange dorsal fins, white tails, and eye-catching vertical blue stripes help identify these beautiful, territorial fish. When they aren't tending their eggs, they take a break to feed on zooplankton and algae.

Longfin bannerfish
(HENIOCHUS ACUMINATUS)
Pot Luck Reef,
Fiji Islands

I never tire of watching these graceful fish. They are abundant in the warm waters of the tropical Pacific. They tend to develop long-term pair bonding, making them among the easiest of my subjects to capture as a duet. The prolific and colorful soft corals on the reefs in the Fiji Islands make for a beautiful background for the bannerfish to be photographed.
—M. W.

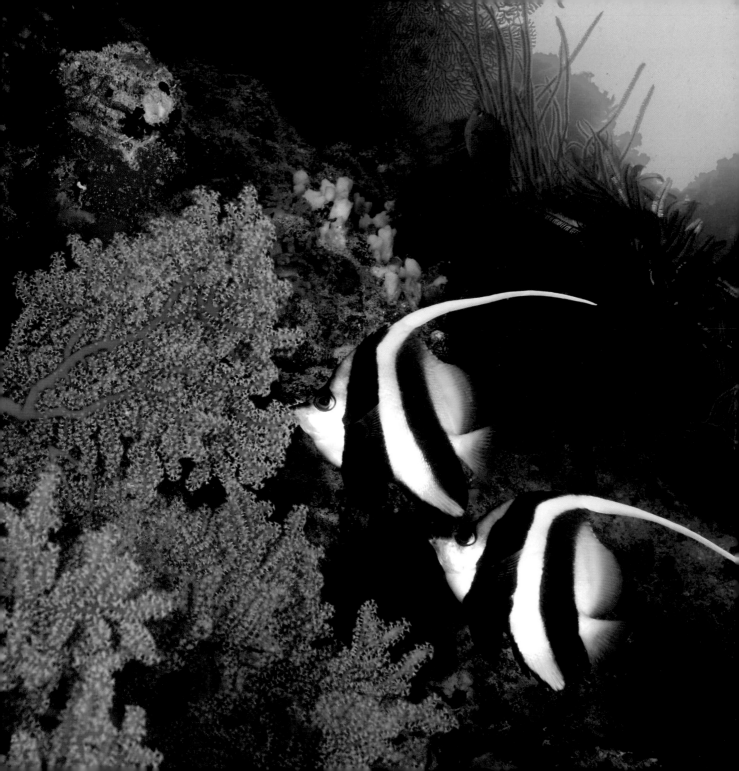

Bigfin reef squid

(SEPIOTEUTHIS LESSONIANA)

Milne Bay,
Papua New Guinea

Ornate ghost pipefish

(SOLENOSTOMUS PARADOXUS)

New Georgia Island,
Solomon Islands

These free-swimming, carnivorous cephalopods—with forward-feeding tentacles and two body-length fins—are jet-propelled. Able to maintain a stationary position with gentle undulations of their lateral fins, a blast from their water jet allows them to quickly move forward or backward. Like octopuses, squid can change color to match their habitat or reflect their mood. Here, the self-illuminated animal is upset. When agitated, the iridescent mollusks can rapidly flash different colors. Even their eye colors change with their emotions.

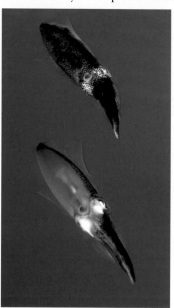

Suspended nearly motionless, head down in the water, these horizontally challenged fish mimic the shape and color of the feather stars, sea pens, and soft corals with which they associate. Covered from head to tail with numerous skin filaments, ghost pipefish occur in a variable patchwork of colors; some are even partially transparent. Females are larger than males and have expanded ventral fins that are used to form a breeding pouch. By clasping their fins together and hooking them to their bodies, the females create a safe place to brood their silvery eggs.

It depends on how upset they are, but bigfin reef squid can blink, flash, and change colors so fast, they look like Las Vegas billboards. Sometimes, the light show can be subtle; other times, they suddenly go nuts. When that happens, I back off immediately, as I hate to disturb them. However, if they really want to get away, they simply squirt their ink and are gone.
—M. W.

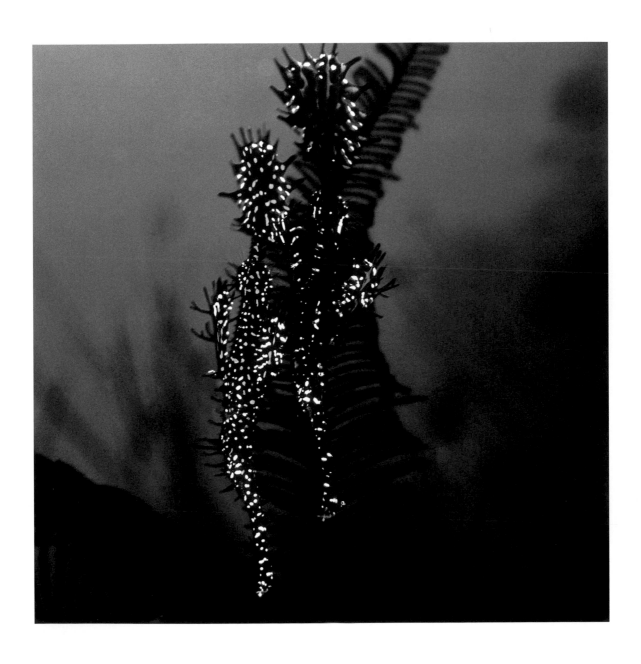

Broadclub cuttlefish

(SEPIA LATIMANS)

West Papua,
Indonesia

The mysterious eye of a cuttlefish hints at its intelligence. Like their octopus relatives, these seemingly innocent mollusks have considerably more brainpower than the average snail. Social cephalopods communicate with each other using their bodies like neon signs to display rapidly changing color patterns. We would be hard pressed to convey as much information as quickly with our facial expressions.

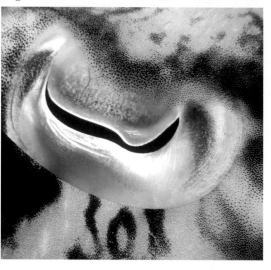

With its protective mate nearby, a female cuttlefish gets ready to lay her eggs. Closely related to squid and octopuses, cuttlefish also use chromatophores located under their skin to make quick color changes. While their inquisitive personalities and humorous appearance make them seem harmless, cuttlefish are skilled predators. With lightning speed, they can shoot their rubbery feeding tentacles at prey, making it possible for them to catch and immobilize a swimming fish twice their size.

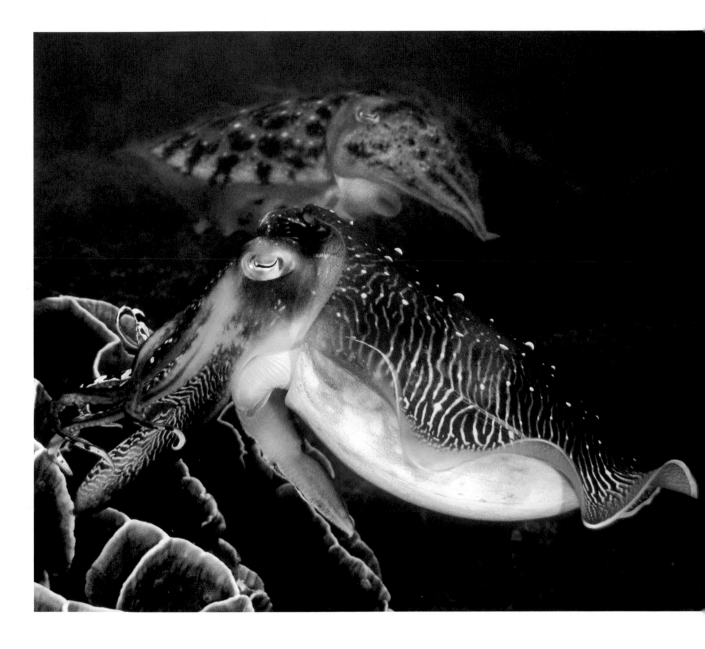

Variegated lizardfish

(SYNODUS VARIEGATUS)

Kavieng,
Papua New Guinea

A pair of variegated lizardfish lies in wait for their next passing meal. These voracious hunters have large mouths lined with needlelike teeth that make it easy for them to capture and dispense with their prey. Named for their reptilian appearance and quick predatory behavior, lizardfish are found on the sand-and-rubble sea bottom throughout the Indo-Pacific.

Twin spot gobies

(SIGNIGOBIUS BIOCELLATUS)

Kimbe Bay,
Papua New Guinea

Hovering above their den, a pair of twin spot gobies attempts to frighten away would-be predators with their large false eyespots. The fake orbs do help make the fish look much bigger—or possibly more like a couple of crazed, bug-eyed crabs. Gobies belong to the most successful family of fish on the coral reefs. These small, usually nondescript fish often remain hidden in crevices, dens, and the branches of coral, making them difficult to see, let alone identify.

The first time I ever saw twin spot gobies, they were the new star on the block for underwater photographers. I liked the way that they traveled, for the most part, in pairs. These bottom-dwellers build and guard their dens in the sand. Most appealing of all is the way they move like miniature hovercraft over the sandy bottom.
—*M. W.*

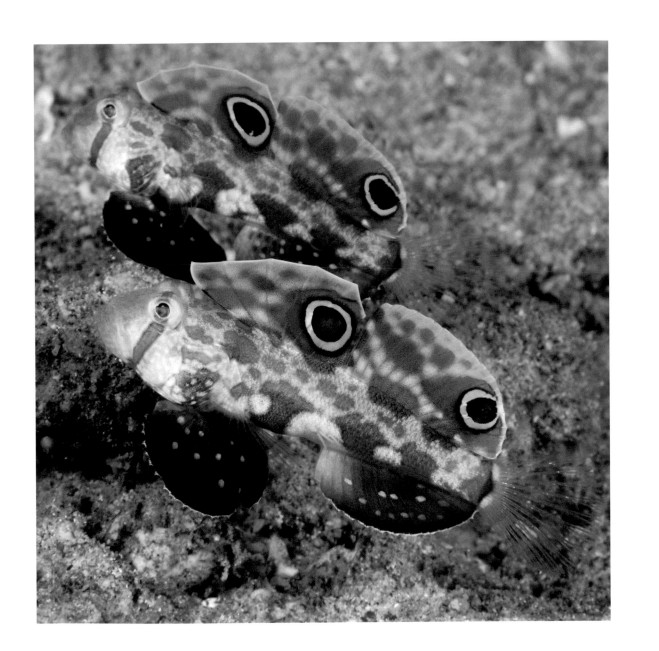

Elegant squat lobsters

(ALLOGALATHEA ELEGANS)

Eastern Fields,
Papua New Guinea

Pink (also called hairy) squat lobsters

(LAURIEA SIAGIANI)

Banda Islands,
Indonesia

Tiny squat lobsters may be common, but they are extremely difficult to see and photograph. The little crustaceans hide under the arms of feather stars, which are in constant motion, since crinoids open and close their feathery arms to feed. As a result, the miniature lobsters are also in perpetual motion, making it a challenge to photograph them in sharp focus. Considered living fossils, crinoids are the ancient ancestors of modern echinoderms, such as sea stars and sea urchins.

Macrophotography makes it possible to visit an underwater world otherwise invisible to the naked terrestrial eye. As if perched on a red planet, these hairy creatures are more closely related to hermit crabs than to lobsters, yet they are named for their lobsterlike claws. Pink squat lobsters are always found on large barrel sponges. At the slightest disturbance, they scurry for cover into the deep folds of the sponge.

Pink squat lobsters are a barrel of fun, but they are extremely difficult to photograph. Because of the sheer size of the barrel sponge on which they hide, it generally takes two people to get an image—one to coax the hairy creatures out into the open, and the photographer to keep a steady hand on the shutter and an eye in the viewfinder. Even then, it is a miracle to get two in the same frame.

—M. W.

U.S. Coast Guard cutter
Duane,
Florida Keys

The *Duane* is a decommis-
sioned U.S. Coast Guard
cutter that was intentionally
sunk in 1987 for use as an
artificial reef. The cutter lies
upright on a sandy bottom in
125 feet of water off Molasses
Reef in the upper Florida
Keys. Now a permanent part
of the Florida Keys National
Marine Sanctuary Shipwreck
Trail, the *Duane* offers
advanced divers the oppor-
tunity to explore an intact
sunken ship that hosts an
impressive community of
pelagic and sedentary
marine life.

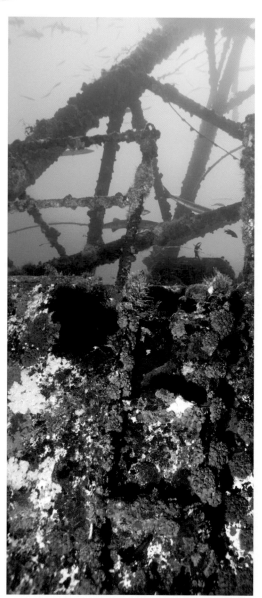

Red-spotted hawkfish
(AMBLYCIRRHITUS PINAS)
Florida Keys

A pair of red-spotted hawk-
fish has made their home
on the *Duane*. Lacking swim
bladders, hawkfish are
bottom-dwellers that use
their pectoral fins to
"perch" on substrates, where
they patiently wait for their
food to float by. Despite
their small size, these comi-
cal fish have big personali-
ties. They watch everything
that moves with their large
eyes and often hop from
spot to spot in anticipation
of a meal.

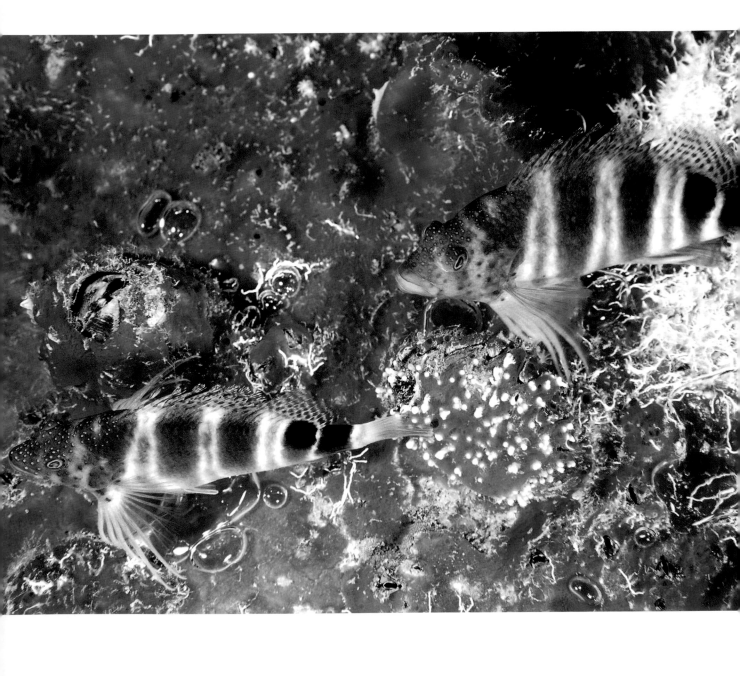

Humpback whales

(MEGAPTERA NOVAEANGLIAE)

Pacific Ocean

Not all pairs in the ocean are male-female. Here, a female humpback and her calf express the close mother-infant bond typical of marine mammals. The mother will guide, teach, and protect her dependent offspring during the long migration to their summer feeding grounds. The vocalizations they share reinforce their bonds and help keep them together.

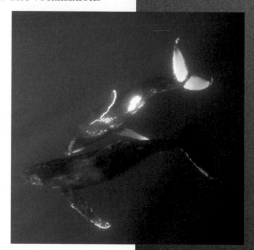

To be in the water with 50-foot mammals
was one of the most memorable experiences of my life.
As I watched the pair dance gracefully together,
I could also hear the tunes they were singing to each
other. From deep, rich notes that would reverberate
through my body to higher pitched chirps, I was
astonished with the beauty of their ballet.
—M. W.

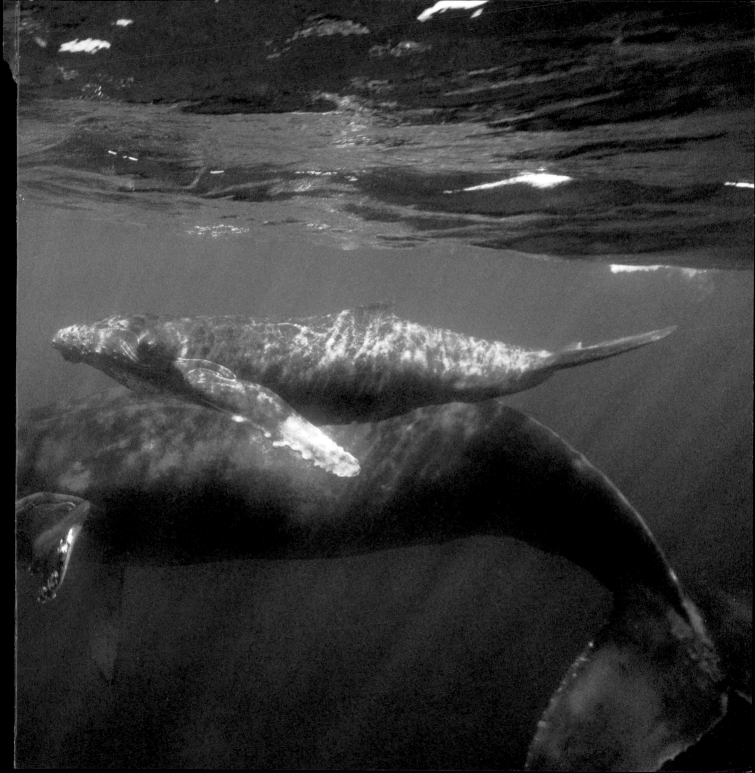

Blue-ringed angelfish

(POMACANTHUS ANNULARIS)

Honiara,

Solomon Islands

California sea lions

(ZALOPHUS CALIFORNIANUS)

La Paz,

Mexico

Angelfish are simply beautiful fish, which is why they appear so frequently in photographs. As juveniles, the blue-ringed angelfish are covered with thin white or light blue stripes swirled against a dark blue background. As adults, they cruise the reefs, browsing on algae, sponges, and the occasional small crustacean. These gems were found on a World War II wreck—death and destruction now life-sustaining.

Although protected by the Marine Mammal Protection Act, these frolicking pinnipeds always seem to be in the middle of controversy—because of their big appetites for endangered salmon stocks, their ability to hop up fish ladders, and their preference for fragile swim platforms and private boats as haul-out sites. It's not so much the lingering essence of fish that they leave behind as it is their direct competition for coveted protein that seems to be the problem.

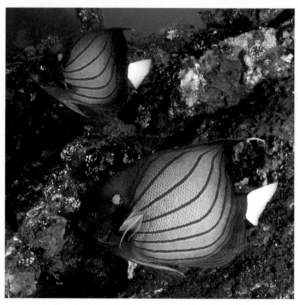

These two juvenile sea lions were hysterical. They were constantly bulleting by me, biting my fins, tossing seaweed, and butting my head. They were so full of energy and so much fun to watch, I wondered if they would ever stop playing. Here, they are captured playing tag with a piece of kelp.

—M. W.

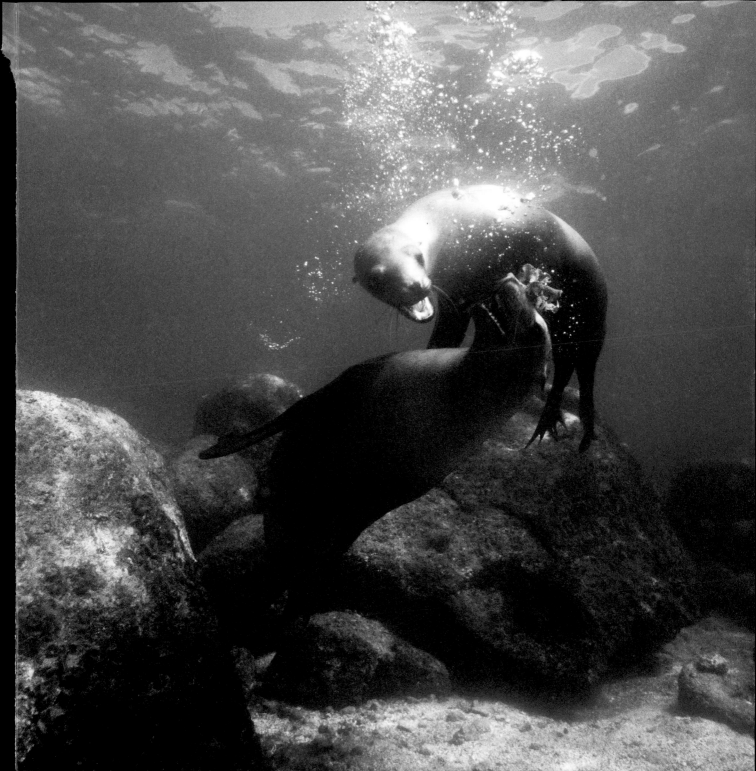

Green sea turtles

(CHELONIA MYDAS)

Bora Bora,
French Polynesia

The fossil record indicates a long history of reptilian adaptation to marine life. Sea turtles remain as part of this evolutionary legacy, having traveled the seas for more than 110 million years and survived the extinction of dinosaurs. Now, they, too, are threatened with extinction by the newcomer—*Homo sapiens.* Here, a young pair of green sea turtles swims safely in the protected waters of Le Méridien Turtle Centre. Named for the green color of their fat, a by-product of grazing on sea grasses and algae, green sea turtles are extraordinary divers and long-distance swimmers.

It was only a few weeks before OCEAN DUETS *went to press that I was finally able to photograph my turtle pair. I had given up on adding turtles to the book, but while on a new assignment in Tahiti, I learned of an amazing turtle conservation program on the island of Bora Bora. Le Méridien Bora Bora resort encompasses a large open lagoon where the hotel staff cares for immature turtles before releasing them into the wild. Here I had the chance to get into the water to photograph, but never in my wildest dreams did I think that two young turtles would swim right into my frame. This image marks a very happy ending to my turtle quest, and a wonderful last addition to* OCEAN DUETS.

—*M. W.*

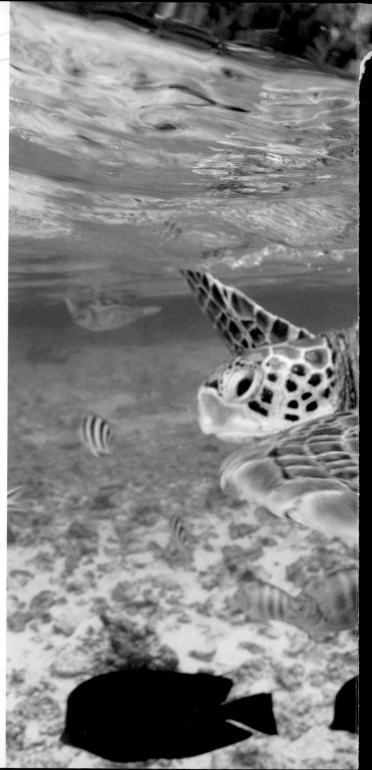

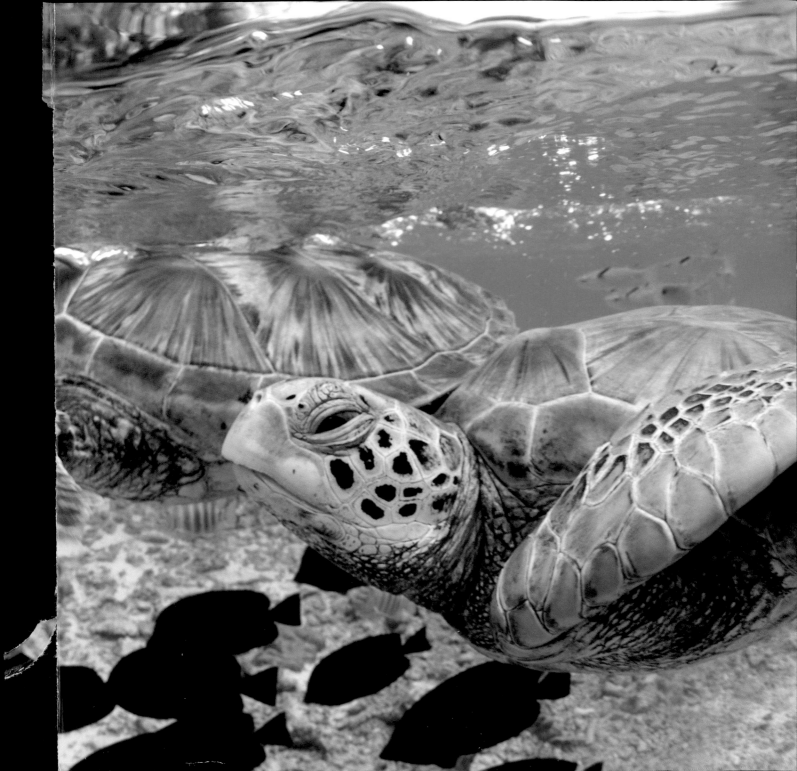

MICHELE WESTMORLAND *is an award-winning wildlife photographer. Capturing images of the amazing underwater world has been her passion for 20 years, six of which have been devoted to extensive travel specifically to photograph "two of a kind" animals. Her work has appeared in many national and international publications such as* Sport Diver, Scuba Diving, Outside, National Geographic Traveler *and* Adventure, *and* Smithsonian. *Westmorland lives with her photographer husband, Stuart, as a partner in Westmorland Photography in Mill Creek, Washington.*

 WINGS WORLDQUEST DEDICATED TO RESEARCHING, PROMOTING AND CELEBRATING THE CONTRIBUTIONS OF EXTRAORDINARY WOMEN EXPLORERS.

 THE INTERNATIONAL LEAGUE OF CONSERVATION PHOTOGRAPHERS — THE ILCP WAS LAUNCHED AS A PLATFORM TO EMPOWER CONSERVATION-MINDED PHOTOGRAPHERS TO USE THEIR TALENTS TO HELP CREATE A CULTURE OF APPRECIATION, UNDERSTANDING, AND STEWARD-SHIP FOR THE NATURAL WORLD.

BARBARA SLEEPER'S *career as a zoologist and science writer has spanned more than 25 years and 80 countries as she has traveled the globe to observe animals in the wild and learn firsthand about conservation issues. She has published nearly 300 wildlife and travel articles and is the author of nine books, including* In the Company of Manatees, Vanishing Act, Our Seattle, *and* Migrations: Animals in Motion. *Sleeper resides in Bothell, Washington with her family.*

TO LEARN MORE ABOUT THE AUTHORS, PLEASE GO TO
WWW.WESTMORLANDPHOTO.COM
WWW.BARBARASLEEPER.COM

Commensal crabs on sea pen

(VIRGULARIA SP.)

Papua New Guinea

ACKNOWLEDGMENTS

If it weren't for the keen eyes and knowledge of the dive masters I worked with in Papua New Guinea, Indonesia, Palau, Mexico, Costa Rica, and Florida, it would have been impossible to photograph many of the "paired" images that appear in this book, including the very smallest inhabitants of the marine world. Over the years, many of the resort operators and dive masters have become some of my closest friends. This book represents the collaborative efforts of many, and I thank the following people from the bottom of my heart for their generous support: Max and Cecilie Benjamin and the Walindi Plantation Resort, Captain Alan Raabe and his remarkable crew on the MV FeBrina and MV Stardancer, Dik Knight and the Loloata Resort, Rob Vanderloos and crew on the MV Chertan, Craig deWitt and crew on the MV Golden Dawn, Kungkungan Bay Resort, Jose Luis and Leslie Sanchez and crew on the MV Solmar V, Avi Klapfer, Yosi Naaman, and crew on the MV Sea Hunter, Navot and Tova Bornovsky of Fish 'n' Fins, who let me "hang around" the Palau dock until I got my mating mandarin fish shot.

My favorite dive masters and guides: Andrew "Digger" Joseph, Elsie Turia, Joseph Yenmoro, the infamous Larry Smith, Ali and Nus from KBR

Jim and Susan Mears, for helping me find new critters in Florida's Intracoastal Waterway

Sandy Jeglum, my dedicated photo assistant

Science Advisor: Gary M. Stolz, Ph.D., U. S. Fish and Wildlife Service